DRAW REALISTIC ANIMALS
wildlife, pets & more

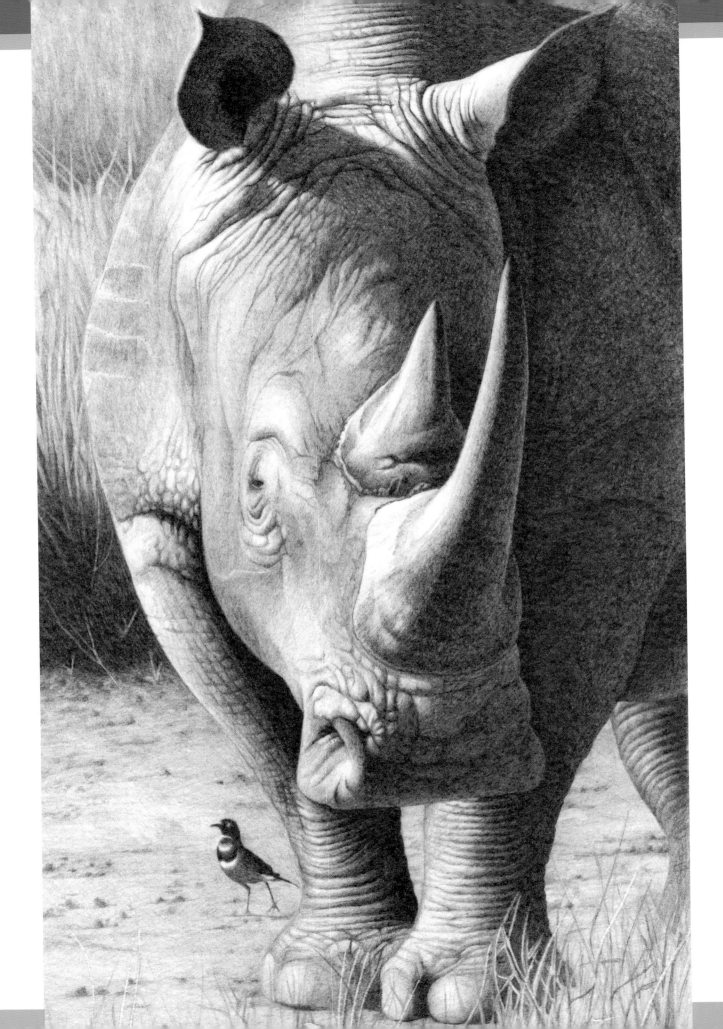

DRAW REALISTIC ANIMALS
wildlife, pets & more

Robert Louis Caldwell

NORTH LIGHT BOOKS
CINCINNATI, OHIO
artistsnetwork.com

Contents

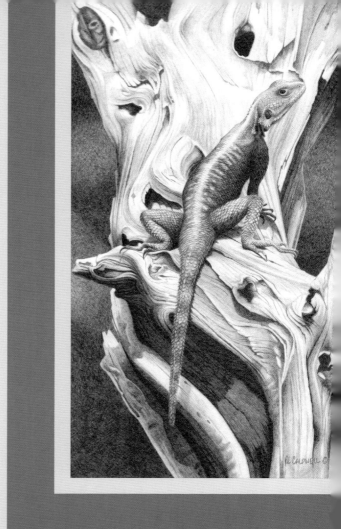

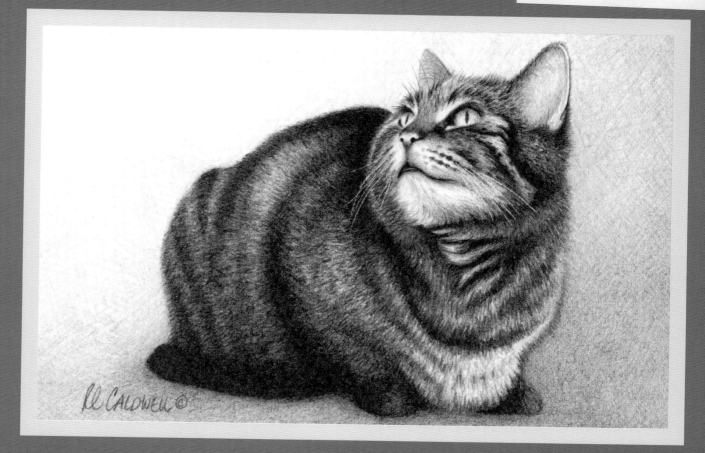

What You Need

Surface
- *Arches #300 (640gsm) cold-pressed watercolor paper*

Graphite
- *4H, 2H, H, HB, 2B, 4B and 6B pencils*

Other
- *craft knife*
- *kneaded eraser*
- *pencil sharpener*

Foreword by Terry Miller

"A drawing is simply a line going for a walk." That quote by Expressionist artist Paul Klee has hovered above my drawing board and acted as a mantra during the two and a half decades that I have been a professional artist. Depicting animals and their world is one of my favorite subjects and, as the 2013 recipient of the Woodson Art Museum's Master Wildlife Artist medallion in recognition of my many years of work in graphite, I am pleased to offer a review of this book on drawing animals.

I first met Robert Louis Caldwell six years ago at the opening of the Woodson Art Museum's internationally acclaimed annual exhibition, Birds in Art, in which his work had been selected for inclusion. Shortly thereafter, we began an ongoing conversation about art, drawing, the medium of graphite and developing well-balanced compositions that continues to this day.

During the past few years, we've both been honored by having our graphite works included in North Light Books' ongoing series, *Strokes of Genius: The Best of Drawing*, and have taken every opportunity to expound upon the virtues of good drawing technique, as well as offering mentorship to young artists.

Good drawing technique certainly begins with the basics; there is no benefit to sidestepping them. If you wish to develop an innate or burgeoning talent, then the detailed and well-defined steps and ideas that Robert provides in the following pages can offer an informed path of guidance.

Any professional must be acquainted with the tools of his or her trade, so an introductory discussion on drawing materials and supplies lays a solid foundation for what follows. Further discussion on the use of elements like value, line, shape and form, linked with making the best use of reference material, adds yet another layer to the basic framework needed for more detailed aspects of drawing preparation covered in the second part of the book.

Robert details the technique of layering to build up darks and develop dimension and depth in a drawing and, closing out the first part of the book, he touches on what I feel is of most importance in structuring a fine drawing: the well-established principles of compositional design. He discusses these principles including ideas such as contrast, movement and rhythm, and applies them to initial studies and sketches before moving them into more finalized contour drawings. He also shows how to prepare to start work on a finished drawing.

The second part of the book is devoted to a number of full step-by-step drawing demonstrations. The text accompanying the images of his works in progress is very detailed and offers thorough technique-based instruction. I was especially taken with his *Hekima (African Elephant)* piece. Like myself, Robert has spent time in Africa, and his love for that particular subject really shows through.

Many lines take many walks throughout the pages of this book. Once set upon the path that those lines take, you should come away from this easy-to-follow resource with a clearer understanding of how, following Robert's informative text and examples, you too can draw realistic animals.

Terry Miller
Takoma Park, Maryland
November, 2013

ABOUT TERRY MILLER

Terry Miller is a renowned graphite artist. His work has garnered major awards and has toured internationally in such reputed exhibitions as Birds in Art, and the Society of Animal Artists annual member's exhibition, Art and the Animal.

Terry also served as Artist in Residence at the Blauvelt Art Museum outside New York City for two years. His residency culminated with the well-received exhibition, Kalahari to Kilimanjaro, in which his works on an African theme were spotlighted.

In 2013, the Woodson Art Museum in Wisconsin honored Terry by naming him as their 33rd Master Wildlife Artist. His works have also been included in volumes 2 through 5 of the North Light Books series, *Strokes of Genius: The Best of Drawing*.

Visit terrymillerstudio.com to learn more about Terry Miller.

(Whiskers) Sumatran Tiger
Graphite on Arches #300 (640gsm)
cold-pressed watercolor paper
9″ × 6″ (23cm × 15cm)

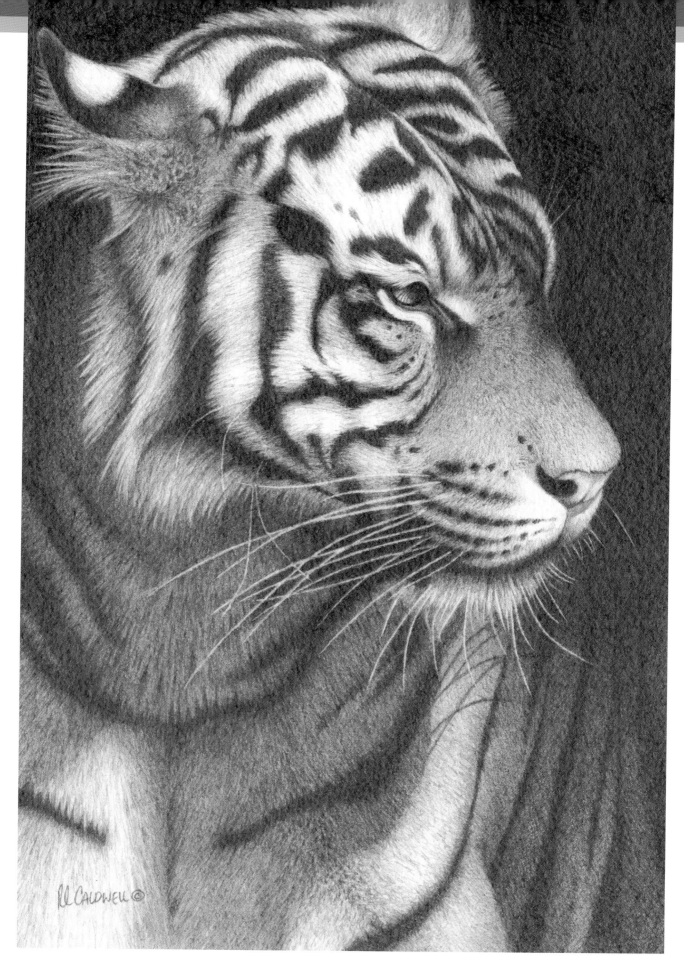

Introduction

Drawing is my passion. I believe drawing is the foundation of all good art. To be able to capture a subject using just an array of values is a powerful thing. At the start, there is nothing but a blank flat surface and a pencil creating lines. The lines create shapes, the shapes create forms, and values describe the forms—all this on a two-dimensional surface creating a three-dimensional image.

Choosing wildlife as the focus for my work seemed to be the most natural selection for me. Since I was a young boy, I loved being outside and watching the living world, taking in all that happens around me. Boy Scouts really fueled my interest in the outdoors. At least once a month I was out in the woods camping, hiking or canoeing. To this day, I still love being out in a tent on the side of a mountain.

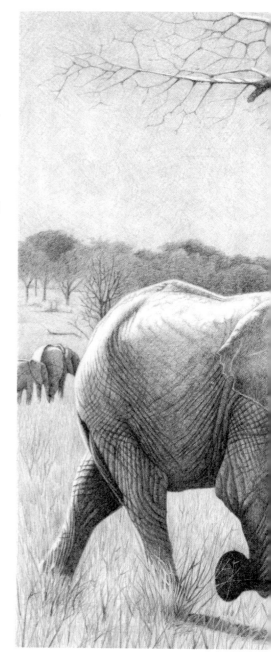

Over the years, I have taken my passion for drawing and my love of animals and created a style of drawing that works for me and gives the same results that I desire every time. I will tell you right up front—it takes patience to get this level of finish in your drawing, but the reward is worth it.

This book will show you how to create the animal drawings that are my subject matter of choice, but this technique of layering graphite to create a continuous tone is universal to any subject matter you may choose. There are no tricks. It simply comes down to soft and hard edges, shift of values and how fast they shift, the length of a pencil line, and whether that pencil line should be visible.

I draw wildlife, but I could just as easily draw a portrait or the spare tire on the back of a jeep. It's all in how you approach your subject matter. Draw what you see and not what you know. Sometimes it can be hard to get the logical side of your brain to turn off. In the end, the drawing in front of us is just a collection of lines and shapes that happens to resemble something like a dog or an elephant.

Drawing is a challenge, so don't make it any more difficult by talking to yourself in a negative manner. If you encounter a difficult section of a drawing and find yourself saying, "I can't do this," or "That's all wrong," the battle is already over and you have lost. Cultivate a positive voice or even better, a questioning voice. Constantly ask yourself, "What is this doing, and how does this shape relate to that shape?" You will find that everything you need to know to make the drawing come to life is right in front of you— just ask yourself the right questions.

It is my hope that you reach the end of this book feeling more confident about your drawing ability than when you first started. No matter what you decide to draw as your subject, it is my desire that you enjoy the process and understand what is needed to create a drawing with the fine detail and subtleties that I so love to create in my work.

Now, let's go scratch some graphite onto paper!

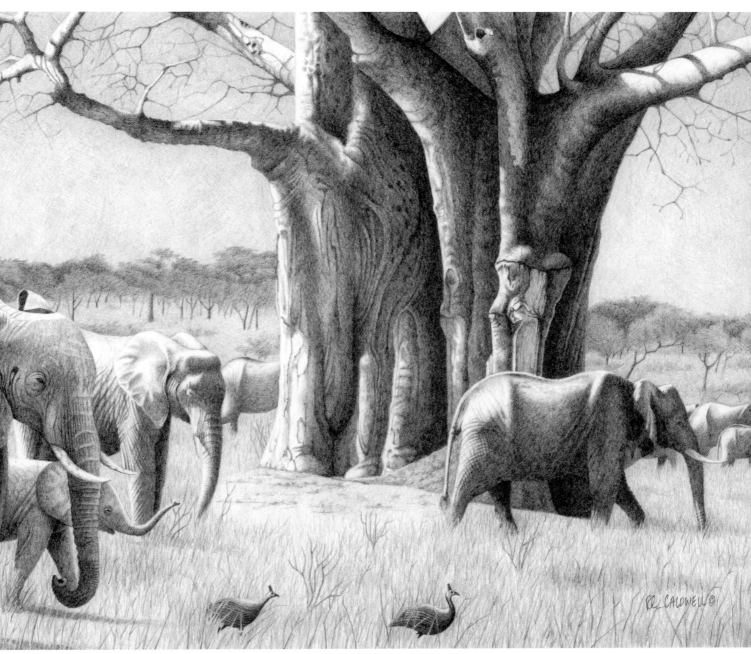

Thirty-Three (African Elephants)
Graphite on Arches #300 (640gsm) cold-pressed
watercolor paper, 10" × 17" (25cm × 43cm)

Part One

Fundamentals

When I talk about fundamentals, I am talking about the basic concepts of drawing—what it is that we are doing and which tools we are using as we draw. There are many different tools that can be used for drawing. A wide range of graphite values and different types of pencils, erasers and papers offer multiple options for achieving various effects. (A pencil sharpener will also come in handy, since keeping a sharp pencil is essential to a successful drawing.)

In essence though, pencils and paper are pretty much all you need to draw. With the combination of these two basic materials, you can create stunning and realistic drawings.

Value, shape, form, lighting and composition are important foundations we will build on when working on the drawings in Part Two.

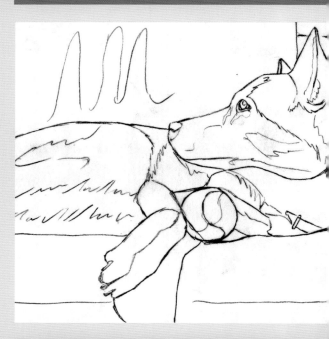

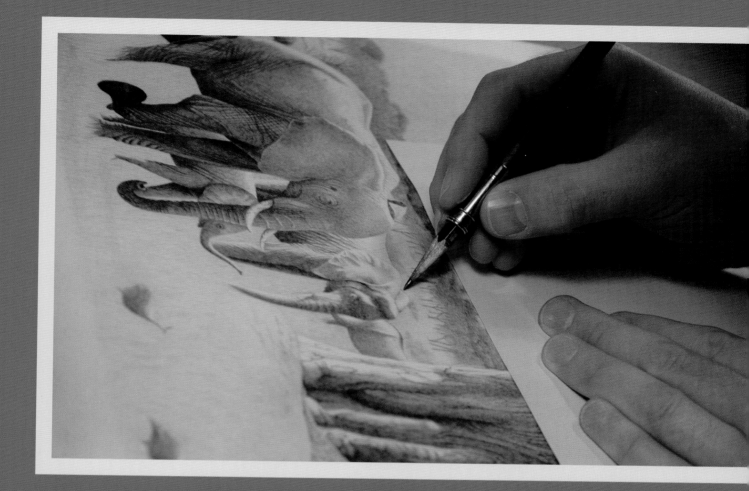

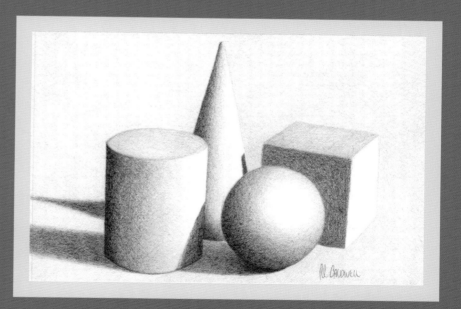

Materials

Graphite

I use a full range of pencils from 9H through 8B in my drawings. Graphite is labeled with a combination of letters and numbers that identify the grade of the pencil. H pencils are the hardest and lightest grades. As the number increases on H side, the graphite gets harder, making it lighter, which leaves less graphite on the paper. On the B side, as the number increases the graphite gets softer and darker, meaning more graphite will be left behind on the paper.

The degree of hardness or blackness is achieved by the proportion of the graphite and clay mixture in the pencil. The more clay it has, the harder the pencil will be.

I have used several different brands over the years, but have settled on Faber-Castell 9000 graphite pencils as my pencils of choice for all my current drawings. This is a personal preference of mine, and I am sure that there are many other fine quality brands that would work just as well. The main thing is to find a brand you like and stick with it. You want to consistently use the same brand over and over again, so that you get used to how the pencil works and can expect the same results from that pencil each time.

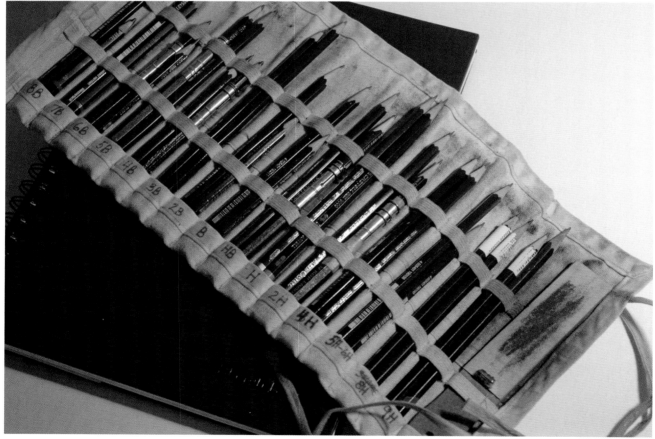

MY PENCIL HOLDER
I made this pencil holder over twelve years ago. It holds my full range of pencils and goes with me everywhere.

Visit artistsnetwork.com/drawrealisticanimals to download a free bonus demonstration.

Paper

You can draw on any surface that accepts a drawing medium, but for our purposes we will cover a few of the more common ones. Sketch paper, drawing paper, bristol board and watercolor paper are all great drawing surfaces. I have found that the tactile relationship of your chosen medium and the substrate that you work on is a very personal one. Take the time to explore different surfaces—you will find the one that best suits your tastes and working habits.

I started out drawing on Strathmore papers myself. Then several years ago, someone introduced me to drawing on cold-pressed watercolor paper, and I have never gone back to anything else. (All of the drawings in this book were drawn on Arches #300 [640gsm] cold-pressed watercolor paper.) I work on this surface because of the amazing darks that can be created with graphite. I also prefer the nice rigid surface that the paper has. The only drawback is that it is made from cotton fiber. So if you accidently pull up one of the fibers, it will act as a magnet to any and all surrounding graphite. Thankfully, those fibers usually work themselves off, or you can use a craft knife to take them off.

ARCHES #300 (640GSM) COLD-PRESSED WATERCOLOR PAPER
Cold-pressed paper has a slight texture giving it more of a tooth, but it is still smooth enough for detailed work. You can also try the hot-pressed watercolor paper. It has no tooth and a very smooth surface.

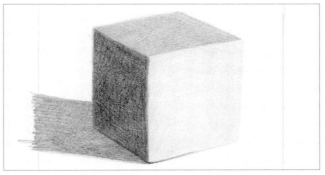

STRATHMORE SKETCH PAPER, SERIES 400: #60 (90GSM)
Sketch paper is a lightweight paper, usually around 60-lbs. (90gsm). It is mainly used for capturing general ideas and quick sketches, or just for experimentation. It is difficult to get rich darks on sketch paper, and it doesn't take too much abuse.

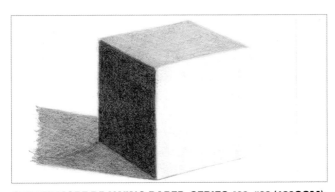

STRATHMORE DRAWING PAPER, SERIES 400: #80 (130GSM)
There are several different levels of drawing papers from student to professional grades. Drawing paper is a thicker, sturdier paper in the area of 80-lbs. (130gsm), with the better quality papers around 100-lbs. (270gsm).

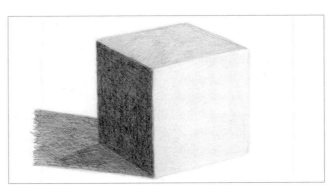

STRATHMORE BRISTOL BOARD, SERIES 300: #100 (270GSM)
Bristol board is basically multi-ply drawing paper. As the number of plies increase, the paper gets stronger and sturdier. It comes in different surfaces including vellum, smooth and plate, which is ultra smooth. I used to love working on the Series 500 4-ply vellum surfaces until I was introduced to the paper I use now.

Erasers

There are basically two types of erasers—rubber erasers for mass removal of graphite and kneaded erasers for lifting graphite. I hardly ever use a rubber eraser and only use a kneaded eraser towards the end of a drawing when I need to lift out any desired highlights. Although these items may be part of your drawing arsenal, I implore you to resist using them. Allow yourself to make mistakes!

KNEADED ERASER

This soft and pliable eraser is an artist's best friend. Do not use it as an "eraser" but as a lifting tool. It lifts the graphite off of a drawing, so it does not harm the surface at all. To clean a kneaded eraser, simply pull it apart, fold it into itself, and mold it back into the shape that you desire.

RUBBER ERASERS

These can be made from rubber, gum or vinyl. When using these erasers, you run the risk of damaging your paper or leaving a film on the surface of your paper. A gum eraser is least likely to damage the paper.

Pencil Sharpeners

As with papers and erasers, there are many choices when it comes to pencil sharpeners—from the type you used in school with the hand crank to the little handheld ones, and of course, electric pencil sharpeners. When I am working in my studio, I use an electric pencil sharpener. I use the little handheld sharpeners only while out of the studio or out in the field.

I also use a small sanding block to get the ultra-sharp point that I like for when I am working on detail and in between sharpening to try and get more life out of my pencils.

You can also sharpen a pencil with a knife. It is very hard to get a uniform point on the pencil this way, but when all else fails, it will do in a pinch.

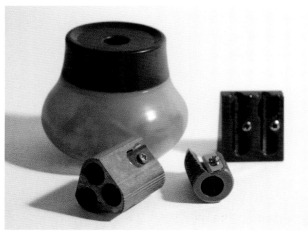

PENCIL SHARPENERS

Manual pencil sharpeners are just that—manual and human powered. They can be the tiny hand-held ones or the wall-mounted ones you see in most schools. These sharpeners create the conical shape of the average pointed pencil. I've had a hand-held "bullet" pencil sharpener for nearly twenty years that I carry with me when I am out in the field. I love it because I can buy replacement blades and keep it working in top condition.

Electric sharpeners work faster and with more precision. There are many different levels of quality electric pencil sharpeners available. I have been using the same one for almost fifteen years, and it's just a standard office model.

Basic Shapes

In art, there are four basic shapes: the cube, the cone, the cylinder and the sphere. Everything in nature can be simplified down to these four basic shapes and their individual characteristics. All of the other stuff is just smaller shapes within the larger simple shapes.

Start with the biggest shapes first and then find the next set of smaller shapes within those larger shapes. Continue repeating this until you have the desired forms laid out in front of you. Then, it's simply a matter of using the values that you create with your pencils to build layers and create volume within the shapes.

The level of finish depends on the amount of time you spend finding all the shapes within the shapes, the quality of your pencil lines, the amount of contrast you put into your drawing, and even the way you talk to yourself. Ask yourself what shapes you are seeing, how a line is moving back in space, whether an edge is soft or hard. The answers are right there in front of you—just stop and ask the questions.

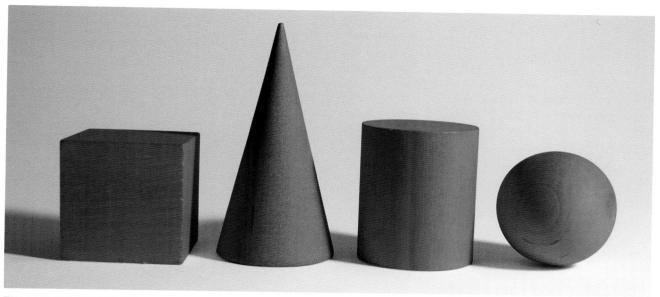

THE FOUR BASIC SHAPES
Most subject matter can be broken down into four basic shapes: cubes, cones, cylinders and spheres.

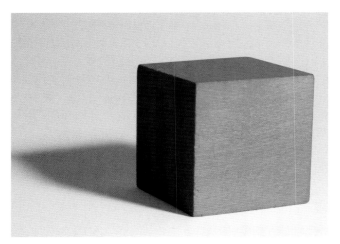

CUBE

The cube is a three-dimensional object that has defined planes or sides of the shape. In most cases, you will be able to see three sides of the shape. For example, the front facing plane, the receding side plane and the top plane are all visible in this image. All three planes will have a solid value describing how much light is hitting the surface. This is the simplest of all the shapes. Many things in nature can be simplified down to a cube.

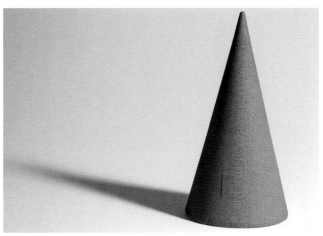

CONE

The cone is one step further away from the cube in that it only has one flat plane—the bottom, which will once again have a solid tonal value. The curved sides of the cone come to a point, so this shape does not have a top.

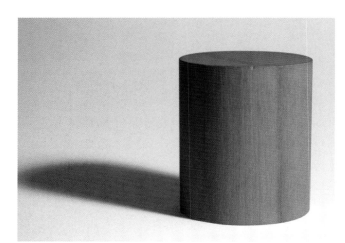

CYLINDER

The cylinder is rounded in form with flat planes at the top and on the bottom. The top and bottom planes resemble the characteristics of the cube in that they will have a flat tonal value, whereas the rounded side of the cylinder will transition in value as it goes from light to dark.

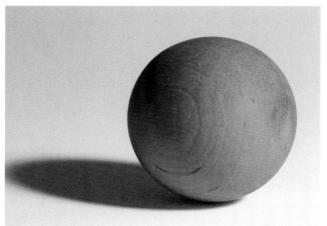

SPHERE

The sphere is the only shape in nature that does not have any flat planes and is completely curved.

Value

Value is the lightness or darkness of an object. It is basically the amount of light you see reflected back from whatever you're looking at. The light tells you everything you need to know about the shapes you see in front of you. Understanding how light falls on the surface of an object will help you create realistic drawings.

A value scale is a great tool to have by your side as you draw. These can be purchased at your local art supply store or you can create one yourself. We will be dealing with the 10-step value scale, 1 being our black and 10 our white.

Working within the limitations of your materials is a very important concept—you cannot replicate all of the two hundred different shades of gray that the human eye can see. Pencils can only produce about ¼ of these values, and for our purposes, we will only concentrate on ten of them. Of course, your drawings will appear to have the perception of more than these ten basic values. Use subtle pencil lines, and our brains will fill in the rest.

Value 1, black, is the darkest dark you can achieve with your pencils on the paper you are using. Value 10, white, will always be the white of your paper. This is why creating your own value scale each time on the paper you intend to use is important. You get to see the physical limitations of your materials, which helps you work better as you move forward.

Some papers, like sketch papers, won't let you get the super rich darks that you desire, but your drawing can still come out nice if you adjust your other values to compensate. You will notice some papers are not as white as others, and some drawing papers actually have a yellowish tint to them. Again, you can adjust your other values accordingly.

A successful drawing will have a full range of values in it, creating a nice balance between the darks and lights. This can also be referred to as contrast. Contrast in a drawing can be used to direct the eye through the picture plane, as well as identifying the focal point of the drawing, which usually has the highest contrast.

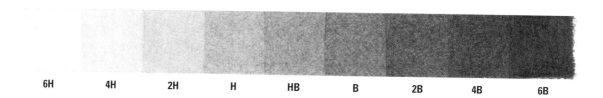

| 6H | 4H | 2H | H | HB | B | 2B | 4B | 6B |

VALUE SCALE

This value scale was drawn on Arches #300 (640gsm) watercolor paper. It was created by layering the different degrees of graphite pencils starting from the 6H pencil (hardest and lightest) and working up to the 6B pencil (softest and darkest).

Modeling the Form

Modeling the form is to give a two-dimensional surface, your paper, the illusion of a three-dimensional object that is solid and has weight. You are creating something where there was nothing before. When modeling simple shapes drawn on the surface of paper, add values to those forms to give the shapes volume or weight. You want to create a three-dimensional form by using light and shadow—value—through the buildup of graphite on the paper surface.

There many ways to build up value and create three-dimensional forms on paper. The two that we will focus on are crosshatching and continuous tone. The drawing demonstrations in this book will focus more on continuous tone. However, we will touch on crosshatching briefly because that is what my continuous tone technique is built upon.

Crosshatching

Crosshatching is the layering of two or more sets of back-and-forth parallel lines that intersect each other, creating a mesh-like pattern. The simplest representation of this is the # sign. This technique can be used to create different values in a drawing by varying the amount of space between the lines, the pencil grade being used, and the amount of pressure being applied to the pencil. Crosshatching can also be used to create patterns in your tonal areas.

Continuous Tone

Continuous tone refers to a value smoothly merging into its neighboring values without creating any distinct separation of values in the subject. No matter how quickly one value shifts to the next, the intention is to make it happen as smoothly as it does in nature.

This is the technique that I use throughout this book and in all of my graphite pencil drawings. It is built upon the crosshatching technique. The main difference is that I keep the length of my lines pretty short, no longer then ½ inch (1.3cm). The smaller the area, the smaller the lines. I also try to keep the spacing very tight without any paper surface showing through.

It's important to back off on the pressure from your hand and let the graphite and the tooth of the paper work together.

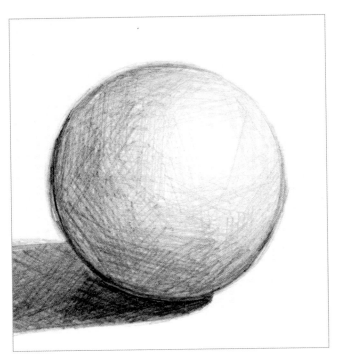

CROSSHATCHING

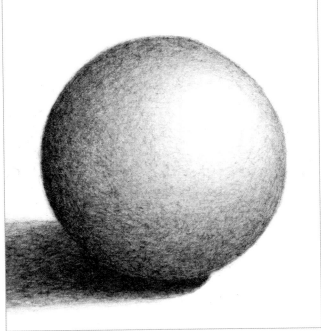

CONTINUOUS TONE

The natural weight of the pencil, sometimes with a little added hand pressure, will work in unison with the paper's tooth to create a solid, even tonal value that has no unwanted pattern or texture besides that of the paper surface, one value at a time. Once you have one value created, move on to the next pencil grade and start layering the next value on top of the previous one.

Hard and Soft Edges

All three of the basic curved shapes have one thing in common: they are rounded forms. Instead of having a value that abruptly stops because the flat plane does, they transition from one value to the next in what is called a soft edge. The harsh lines of the planes on a cube are called hard edges.

This soft edge present in rounded forms is what is known as the line of the core shadow. This is the point at which you can identify one side as the lighter side and the other as the side in shadow. When drawing the line that identifies the core shadow, don't make it too dark—it's an area on the surface of the shape that transitions in value subtly.

The key to seeing the objects you want to draw is to simplify them into one of the four basic shapes to train your mind to see three-dimensionally. Stop and ask what shape you're seeing and how that shape is moving back in space on your two-dimensional surface. You can then describe that shape (modeling) with the use of hard and soft edges.

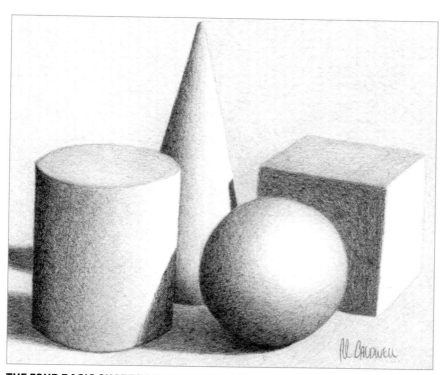

THE FOUR BASIC SHAPES DRAWN USING CONTINUOUS TONE

TIPS FOR APPLYING CONTINUOUS TONE

- Don't apply too much hand pressure as you build your layers of value. Resist the temptation to press hard with your pencil to create a darker value. This crushes the tooth of the paper, creating an ultra smooth surface. If your paper gets to this point, it cannot be fixed.

- Hold your pencil at a 45-degree angle. Periodically turn it in your fingers to keep a fresh point.

- Each pencil grade reaches a point where it just won't give you any more value. When you feel your hand choking up on the pencil, that is the signal to move on to the next grade.

- Keep your pencils sharp! I cannot express how important this is. The sharper the point of the pencil, the less surface area the tip of the pencil has. This gives you a lot more control over your line quality.

Lighting

Always pay attention to lighting—where it is coming from, how it is illuminating the object you want to draw, and what the shadows are doing. Whether drawing from life or trying to capture reference on film, the one question you should repeatedly ask yourself is, "Where are the shadows?" Shadows show the direction of the light and confirm you have a good light that will help to describe the forms of your subjects.

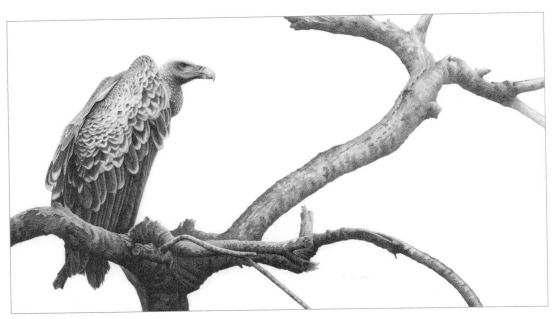

LOW-CONTRAST LIGHTING

My drawing *Custodian (Rüppell's Vulture)* has a very soft and subtle lighting to convey the overcast day, as well as the stark feeling of dread that you feel when seeing a vulture.

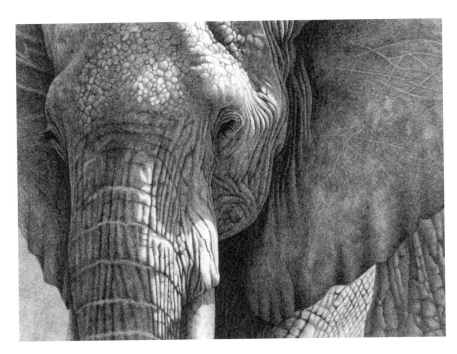

HIGH-CONTRAST LIGHTING

My drawing *Hekima (African Elephant)* has a very high contrast lighting, which resembles the actual lighting of Africa. This high contrast also helps to create the illusion that the elephant is getting ready to come off the paper.

Visit artistsnetwork.com/drawrealisticanimals to download a free bonus demonstration.

Layering Graphite

Layering is as important to my drawings as the continuous tone technique is. Every one of my drawings is composed of layered graphite—one pencil grade on top of the next.

When layering graphite on cold-pressed watercolor paper, build one level on top of another. Start with your lightest (hardest) pencil and work your way up through each darker (softer) pencil grade until you get to your desired value. That first light layer is key, as it sets the foundation for all the other layers of value.

This technique of layering the graphite in order from light to dark is very important to achieving a solid tonal mass. Imagine you are looking at a piece of paper under a microscope. The tooth of the paper would be like hills and valleys. The initial light pencil layer would fill in all of the hill tops and valleys. The next darker layer would do just about the same, but not reach all the way down into the valleys. Each successive layer would reach down less and less. Once finished, you would have a very nice solid tonal mass.

The solid tones you create will give a realistic look to your finished drawings. They allow you to achieve subtly shifting values because the lighter layers of value under the darker ones provide the foundation.

Patience is the key. Those first two layers especially seem to take the longest to block in. It can be a long and sometimes tedious process, and the only secret to it is patience.

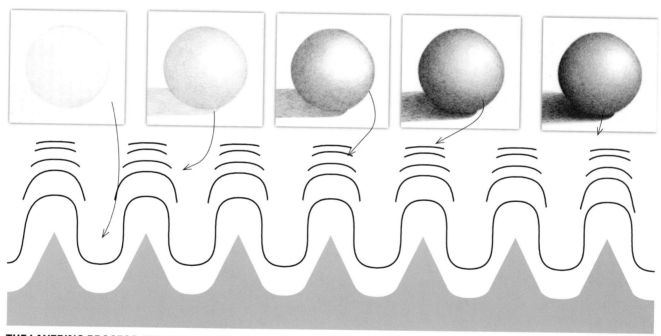

THE LAYERING PROCESS AT WORK ON PAPER
Each successive layer reaches into the tooth of the paper less and less.

Reference

Reference material is essential. Gather reference as often and as much as possible. I generally have a camera with me at all times because I never know when I will see something that might strike me enough to want to use it in a future drawing. An image from four years ago might work with a new image from yesterday.

Collecting reference material also puts you out into the field, observing the subjects that you want to draw and how they interact with their habitat. Observing wildlife in the field will more often than not inspire your next drawing. That is when your sketchbook will come into play. Write down the idea for a piece, capturing what you saw that inspired the current idea at hand, and maybe quickly sketch out the general concept too.

You don't need to go far to get your own reference. A simple drive down some country roads will supply you with enough reference for many drawings. A trip to your local zoo will give you great practice with drawing wildlife. Even a walk down a busy street can give you plenty of reference to draw from. The great thing about drawing wildlife is that it is all around us. You don't have to travel to exotic places, because your own backyard is a great place to get started.

The tools for gathering reference can be anything from a simple point-and-shoot camera to a very expensive DSLR camera with a 500mm lens. What is important is that the camera takes clear in-focus pictures. Depending on the length of your reference gathering trip, carry the appropriate amount of memory cards and backup drives too. Always bring more than you think you will need. Practice patience when photographing animals and watch their behavior to anticipate where they will move next so that you may get a better angle.

Also, be very aware of your lighting. The light adds drama and helps to describe the animal's form. Always ask yourself where the shadow is. If you don't see one, move.

It is good practice to have a small sketchbook or notebook on hand as well. Jot down field notes or a sketch to make a record of what you see. I use a hardbound sketchbook and simple mechanical pencil when in the field. I do not want to create museum quality drawings, I just want to capture the essence of an idea or make notes about what I'm seeing. If it is an extended reference trip, I dedicate a sketchbook to just that trip, which makes it easy to reference later.

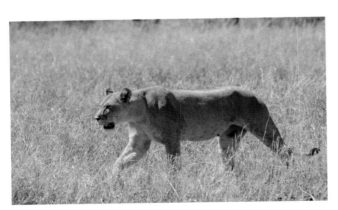

REFERENCE PHOTOGRAPH
A photo reference image captured in Tanzania. It later inspired the drawing *Margin (Lioness)*.

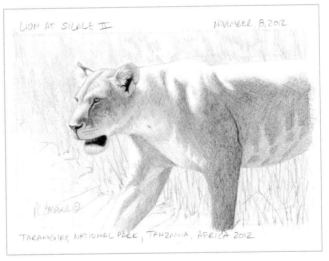

FIELD SKETCH
Capture as much reference as possible and make many notes and sketches when in the field. With your sketchbook notes and sketches, you can revisit the ideas you had in the field to see if they can be expanded on and if there is an actual drawing there. Most often, your notes about the day—weather conditions, how the light was hitting the ground, etc.—will be more valuable than the sketches themselves. It's these details that help to create an awe-inspiring composition.

Bad Reference

Bad reference is often really noticeable and can easily be disregarded. Be wary of what the camera lens can do; focal length can alter an image a lot. A short focal length can curve straight lines, whereas a long focal length can compress an image, taking away some of the depth. The reference that you collect is a tool and inspiration for your work, but don't become tied down by it. Don't draw everything you see in the reference photo. Look for the camera alterations in the image. Just because it's in the photo doesn't mean your drawing has to have it. Sometimes less is more.

BLURRY REFERENCE
Sometimes bad reference is as obvious as an out-of-focus image.

LENS ARCH DISTORTION
Here you can see the support poles arching due to lens distortion. This would need to be corrected in your drawing.

Using More Than One Reference

Consider it lucky when you capture exactly what you want in one reference photo—it doesn't happen often. I usually shoot for two different types of images—subject matter first and habitat second. Capture the whole animal first and then back off some to get the habitat. Then you can start to zoom in and get detail shots. If the animal is on the move, try to get it at different angles with different lighting, or even try to capture some movement action. Animals in motion will always add drama to a drawing.

With habitat settings, look at the shapes and lines that are in front of you. Often this will be when a possible composition starts to come to life. Ask yourself how those lines are moving through space. Do they create visual movement? Are there too many spaces? Is there a place for my eye to rest? The questions can go on. Usually, there is a habitat setting that interests me, and then I will have to find a subject to fit into it, or I have a really good reference of an animal and need to find a habitat to place it in. The most important thing is to not hold yourself to one reference but use many to create your own scene.

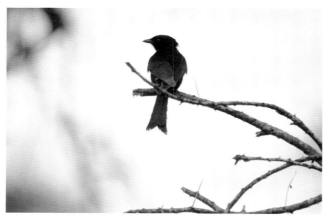

SUBJECT
Subject reference photo for the drawing
Whistling Fork (Fork-Tailed Drongo).

HABITAT
The perch for the drawing *Whistling Fork (Fork-Tailed Drongo).*

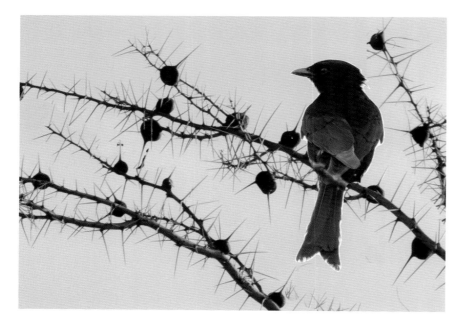

COMBINATION REFERENCE
This is the composed photo reference that I created for the drawing, *Whistling Fork (Fork-Tailed Drongo).*

Composition

Composition is an orderly arrangement of the elements of art using the principles of design. It is one thing to be able to reproduce an image, but it is a whole different ability to be able to make a finished drawing into something that captures the viewer's attention. You want the viewer to stop and look at the drawing, to visually move around inside of the picture plane and not get stuck anywhere that you don't want them to. You as the artist determine that path through careful planning of the composition.

The Elements of Art

The elements of art are the basic visual components used when creating a piece. They are line, shape, color, form, space, value and texture. A simple mark made within a square box is a use of the elements line and space. These elements are the artist's visual tools to create—be it realism or abstract, sculpture or drawing—they are most fundamental aspects of our creations.

LINE
There are two types of lines: the linear marks made with your pencil and the lines that are created when two shapes meet. The second type can also be a perceived line that is not a deliberate physical line you have drawn, but one that has been created. A horizon line or tree line is a good example of this type of line. Be aware of how this type of line breaks up the picture plane.

SPACE
This is the area within and around the parts of the drawing. There are two types of space: positive and negative space. Positive space is the shapes that represent a subject matter or something identifiable within the picture plane. Negative space refers to space around and between the subject matter. Space includes the foreground, middle ground and background. When composing an image, this is usually the first thing that you decide on; what the space will be that you are creating in.

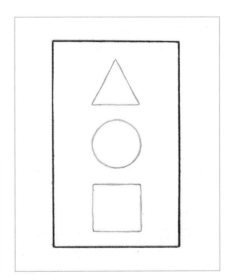

SHAPE
A shape is an enclosed area of space that is used for a particular purpose, usually to define the boundaries of an object that you want to draw. A shape can be geometric or organic. Negative shapes can be just as useful as the positive shapes when first sketching out your idea.

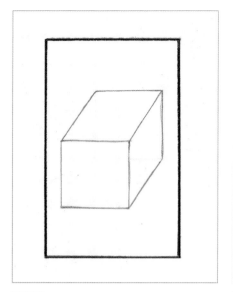

FORM

Form is a three-dimensional object that is created by combing two or more shapes which can be measured from top to bottom, side to side and from back to front. These shapes then can be defined by light and dark, also known as value/tone.

VALUE/TONE

The lightness or darkness of color is also known as value, or tone. This is the element that helps to define form and give objects depth and perception.

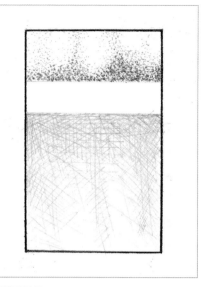

TEXTURE

Texture is the surface quality of the shape—rough, smooth, soft, hard, etc. For our purposes, it is a perceived texture and not a physical texture.

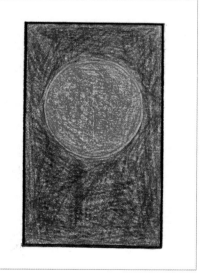

COLOR

Color is also known as hue. It is seen by light reflecting off of a surface. All colors have inherent values and will change in hue based on the amount of light saturating them. (We won't discuss color any further in this book, since we are working in graphite.)

RULE OF THIRDS

The Rule of Thirds is the most basic compositional concept and should be considered the default setting for anything you create. The concept is simple: Use lines to divide your picture window into thirds vertically and horizontally. The points where those lines intersect are the best places for your subject or point of interest. Place your main focal point at one of these intersections and maybe a second, less important item of interest at another. Don't use the other intersections. Let those become part of the overall picture plane, a balance for your main subject. This will work with any size picture window you create. Most cameras have the ability to superimpose a grid onto your view finder, and it will usually be a grid based on the Rule of Thirds.

The Principles of Design

The principles of design are a set of rules (more like guidelines) on how to create a visually pleasing arrangement of art using the elements. A beginning artist should look at these as rules, whereas a more seasoned artist will use them more as guidelines, trying to stretch them as far as they can go. You have to study these principles and fully understand them before you can bend them. The principles of design are balance, contrast, movement, emphasis, pattern, rhythm and unity. An artist does not just create haphazardly, but instead uses these principles to create a finished piece, controlling how the viewer will look at the finished piece.

When composing your next piece, focus on just one of these principles first and don't bog yourself down trying to use all of them in a composition. They're not all not needed. Sometimes you will find yourself combining a couple of them to achieve another. For example, you might use pattern or rhythm to create movement in your drawing, which in turn directs your eye to the focal point. All good art has a good underlying composition. In realism that underlying, almost abstract structure can be hard to see due to all the detail but it is still essential.

CONTRAST

Contrast is created by the use of value, pattern or texture, or a combination of these. Contrast can create visual excitement in a piece and pull you towards an area of your drawing, or the lack of contrast can keep you from dwelling in one area too long.

PATTERN

Pattern is a repetition of the elements within your picture plane. Pattern can either be planned or random and is usually used to help create some visual excitement that helps to move your eye through the drawing.

MOVEMENT

Movement refers to the path that the viewer's eye takes through the drawing. It is created by the use of line, edges, shapes and texture. The perceived movement of a subject within the picture plane and the direction a subject is looking can also be movement in a drawing.

BALANCE

Balance is a visual equilibrium that is like our physical sense of balance in that the object of our attention can tip over. In art, it wouldn't actually tip over but would look odd and visually uncomfortable. You can achieve visual balance in your work with two basic types of balance: symmetrical and asymmetrical.

RHYTHM

Rhythm is almost a timed visual repetition of the elements in a picture plane. It is a predictable movement through the space of a drawing and can bring a sense of order to your piece.

EMPHASIS

Emphasis is also called the focal point or point of interest. It is the location in the drawing that you want the viewer to focus on and pay the most attention to. Almost all compositions will have a main focal point and sometimes a secondary focal point. This is the most important principle. It's the reason we are looking at the drawing.

UNITY

Unity is the underlying principle that summarizes all the principles and elements of design. It refers to the whole and the sense that everything within the drawing is coming together.

SYMMETRICAL VS. ASYMMETRICAL BALANCE

Symmetrical balance, or formal balance, has equal weight on both sides of a centrally placed fulcrum. With the elements arranged equally on either side of the central line, whether being vertical or horizontal, the result will be a symmetrically balanced picture plane. This is considered a safe but boring composition.

Asymmetrical balance, or informal balance, is more complex. Elements in a drawing are arranged in a composition based on the amount of visual weight they have. The easiest way to see this is to imagine a balance scale with a different amount of weight on either side of the fulcrum point. To balance the heavier weight, you need to push the lighter weight further from the fulcrum point.

The Composition Sketch

My drawings start with an idea or inspiration from reference material I have collected over the years from my adventures in the field. I use photographs or my quick field sketches as reference for creating a composition in Photoshop® on my computer. I figure out what the composition and size of my drawing will be before I even begin the drawing.

Draw your initial composition sketch in your sketchbook. This is where you can get the shapes figured out and make all your mistakes and corrections. This way of working takes the pressure off when you start the actual drawing because by that point, you will already feel confident about the shapes you've drawn.

Another reason for completely composing a drawing before you actually begin to draw is to figure out the picture window. From there, convert the proportions from your sketchbook sketch to the finished drawing size. That way, the photo reference, composition sketch and final drawing are all in proportion to one another. You can move forward knowing that the sketch, once transferred and enlarged, will fit perfectly into your final drawing.

When sketching, revert back to finding the most basic shapes in the subject. Strip away all details. Use the negative shapes around the positive shapes of the subject to visually measure the spaces between the subject and the edges of the picture plane. The most common artistic name for this is called *sighting* or *visual measurement*.

Use the parallel edges of the picture window to help judge the distance between the shapes in the drawing. I often drop perpendicular lines from these edges to give myself a visual guide when drawing. By the time you finish sketching, you can almost see an impromptu grid system on the drawing surface. I call these my searching lines. Once the larger shapes are in place, all of the smaller shapes fall right in step.

The hardest part at this stage is avoiding the temptation to jump right into the details of the drawing. However, it is important to get the foundation down first—without it, there is nothing for the details to rest upon.

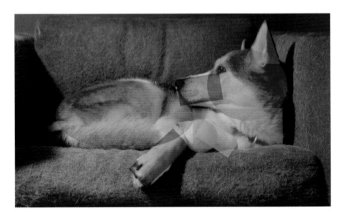

REFERENCE PHOTO
Reference photo for the drawing *Brody (Dog)* with basic shapes superimposed on top.

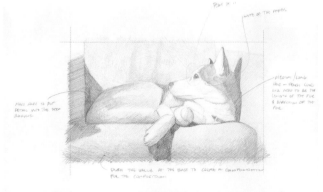

COMPOSITION SKETCH
Composition sketch for *Brody (Dog)* done in my sketchbook with reference notes on where to establish more details, focal point of the drawing, and where to push darks in order to pull out the lights.

Use Photo Reference to Plan a Composition

My drawing, *Thirty-Three*, was composed from seven different reference photos. I shot them on an early morning game drive while on safari last year. Although none of the photos captured the overall majestic feeling of witnessing that herd of elephants moving across the plains, I did end up with many different reference images that would work to create a great composition.

I scan my photos into my computer and then compose in Photoshop®. This way, I can use the layers and resize images as I construct my composition. Once I'm happy with my photo composition, I print it out and create my initial sketch.

If you don't have Photoshop®, you can create sketches on tracing paper and use a light table to move the different elements of the composition around until you are happy with it. Use a photocopier to enlarge or reduce elements to the desired size before inserting them into your composition. Once everything is in place, tape the pieces together and then trace the entire composed image onto a new fresh sheet of tracing paper.

Materials

- *reference photos*
- *Photoshop® and scanner, OR*
- *light table, pencil, photocopier and tracing paper*

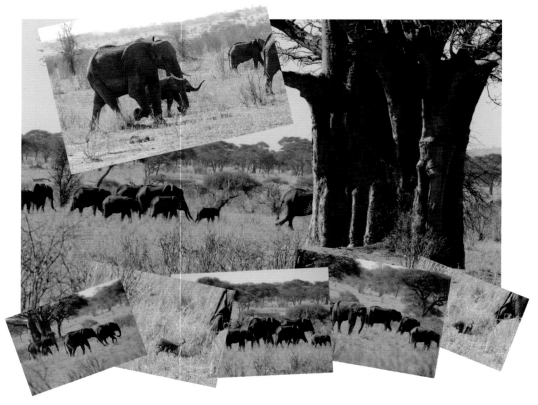

REFERENCE PHOTOS

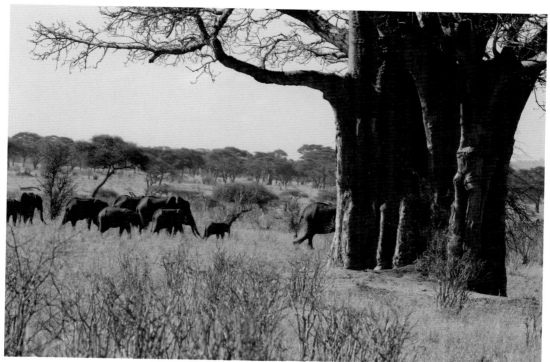

1 CHOOSE YOUR BASE IMAGE

Begin by deciding what your base image will be. The base image is usually the background of the drawing. This is the scenery of the story you are about to visually tell. Although you're focusing on the background at this stage, you should already have an idea of where you want to insert the subject of the drawing.

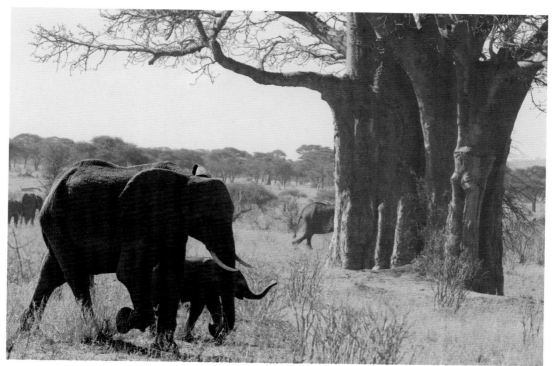

2 PLACE THE MAIN SUBJECT

Place your main subject (in this case, the mother and baby elephant) into the setting you have chosen. Watch the size of your subject; make sure it works within the plane of the setting. Also, pay attention to the perceived lines that can be created. For instance, you wouldn't want to put the elephant any higher because the line of its back would be on the same line as the top of the tree line.

3 BALANCE THINGS OUT

The mother and baby elephants don't feel visually heavy enough to counterbalance the large Baobab tree. Another elephant is inserted directly behind the mother and baby. Now the composition has a bit more balance to it.

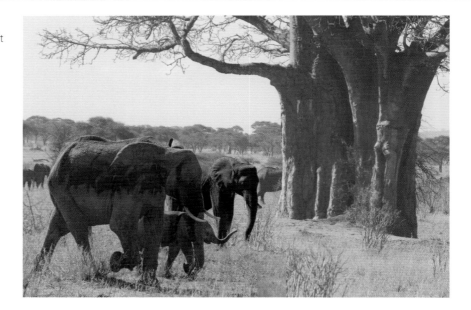

4 FILL OUT THE PICTURE PLANE

The established picture plane is filled up some more by inserting additional elephants to the right of the tree. This also helps to create some visual movement in the drawing because the eye naturally wants to follow the direction the elephants are moving.

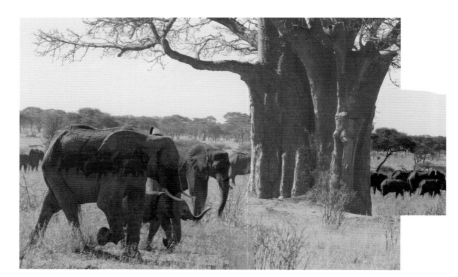

5 ADD DEPTH

To add more depth needed for this piece, one more elephant was placed in front of the tree. This layered look helps to create visual depth. There is now a perceived line along the foreground and mid ground elephants' backs and at the bases of their feet. That perceived line creates a wedge shape that increases the visual movement from left to right in the composition.

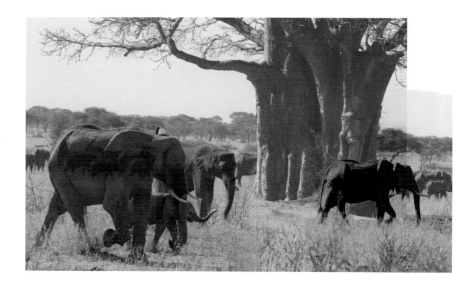

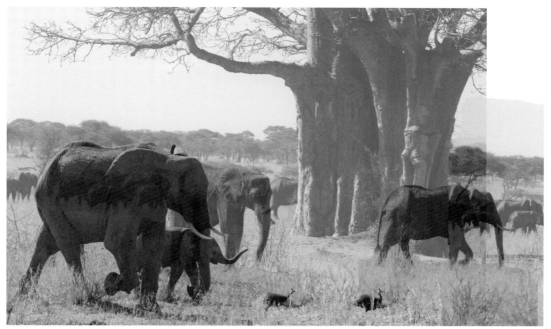

6 ADD FINAL ELEMENTS
The visual movement from the left to the right of the piece needs to be increased a bit more. Two guinea fowl were added to look like they are running away from the elephants. This will help to increase the movement and also add a bit of excitement to the drawing.

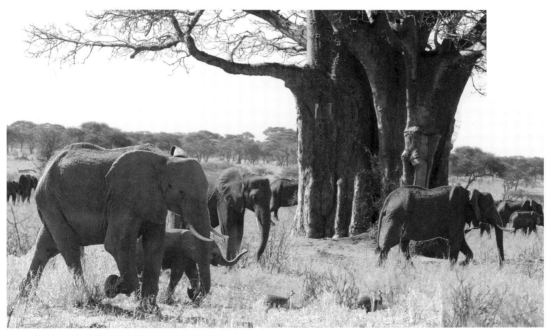

7 CONVERT TO BLACK AND WHITE
The reference is now ready to be used to create the composition sketch. Before you start sketching though, convert the reference photo into black and white. That way you don't have to worry about converting the colors into graphite values as you draw.

Create a Composition Sketch and Contour Drawing

Now let's work our way from the initial reference through the composition sketch to the contour drawing, which will then be transferred to the final drawing surface. (The actual layered graphite drawing will be demonstrated later.)

This sketching process is fairly quick. I limit myself to no more than 2-3 hours to sketch out my initial composition. Keep focused on finding the general shapes and don't get lost in the details. If you find yourself focusing more on the little things because the general shapes are all blocked in, then it's time to stop.

Instead of putting those details in, make notes of where you want to establish more details, what the focus of the drawing is, and where to push your darks more so that you can pull out the lights. Refer to these notes as you work on your final drawing. Over the years, I have found that my initial ideas about a drawing are usually pretty good choices, but they can get lost once I start the drawing, so keeping notes is essential.

Materials

- *reference photo*
- *sketchbook*
- *4H, 2H and HB pencils*
- *tracing paper*
- *masking tape*

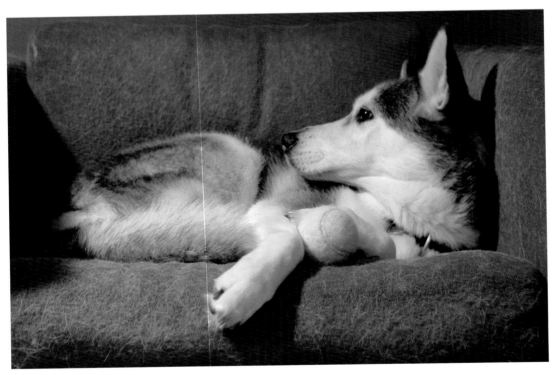

REFERENCE PHOTO

This is my reference for the drawing *Brody (Dog)*. The original image was large and included more of the surrounding room that I didn't feel was necessary for the drawing. I decided to make the dog's eye the focal point of the drawing, putting it onto the Rule of Thirds grid. The large negative shape of the chair on the left balances with the hard direct stare of the dog. Because the dog is looking left, we automatically follow the dog's gaze into that space.

1 BLOCK IN THE LARGE BASIC SHAPES

Start with a 4H pencil and drop down the perpendicular line at the top right in front of the circle that will become the dog's head. From there you can drop a visual marker, the parallel line at the end of what will be the dog's nose. This line almost marks the center line of the drawing. Likewise, the horizontal line that is parallel to the top and bottom picture plane marks the horizontal center line of the drawing.

Block in the most basic shapes: the circle (sphere) of the head, the triangles (cones) of the ears, and the cube-like shape of the snout. Most of these lines are likely in the wrong place and will need to be adjusted as you move forward. That's OK!

2 BLOCK IN THE SMALLER SHAPES

Continue with a 4H pencil and quickly draw in the basic shape of the seat cushion. Look at where the line that makes up the top of the cushion intersects with the left and right sides of the picture window, about one-third of the way up. The arm of the chair creates another large simple shape to be blocked in.

Draw in the large oval of the dog's body. It fits comfortably within the lines of the bigger shapes you just drew. The top of the large oval should not extend past the line that comes out from the top of the dog's snout. If you need to draw in a searching line for this part, feel free to do so—it's just a sketch. Block in the general shapes of the front paw and the tennis ball. The shadow under the front paw makes a great shape to help break up the larger shape of the seat cushion because it is directly in the middle. Block in the dog's eye as well.

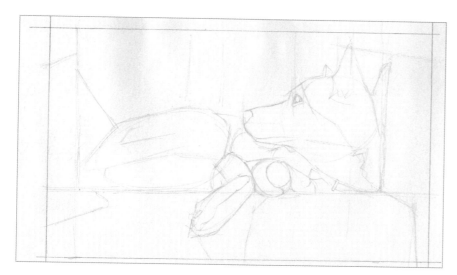

3 BEGIN BREAKING UP SHAPES

Use a 4H pencil to draw four simple lines to create the shadows and the top of the arm of the chair. Separate the larger shapes of the dog's paw and rear body by drawing in the boundary line of the core shadow. Add a boundary line to the dog's face and an *S*-shaped line on the tennis ball to break those shapes up.

Begin building up the eye using the negative spaces around it to ensure it's placed correctly.

4 LAY IN SOME BASE VALUES

Block in the first layer of value in the core shadows with a 4H pencil.

Since this is just a sketch, don't worry so much about your line quality— just begin to block in the values. All you need to do is get an idea what you are going to push back and what you want to pull forward.

You should not need your eraser to fix anything, because the values that you're blocking in cover up all those lines you either don't need or that are mistakes.

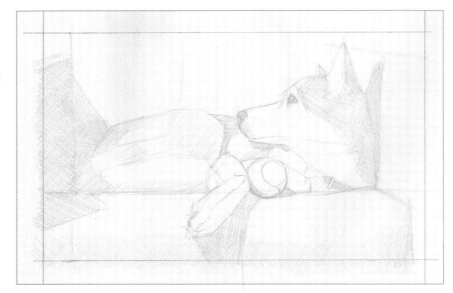

5 ESTABLISH THE CORE SHADOWS AND BLOCK IN LOCAL VALUE

Establish the core shadows with another layer of value using a 2H pencil. Then block in some of the local value with a 4H pencil. Local value is an object's inherent value without any direct light or shadow affecting it. Once you have this drawn in, use an HB pencil to work in some of the subtlety that will help in creating the contour drawing. The creases in the back cushion are a good example of working in subtlety.

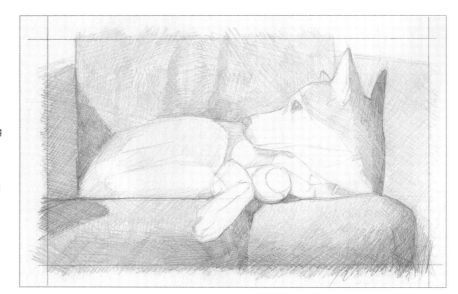

6 FINISH THE SHADOW SHAPES

Use an HB pencil to finish establishing shapes in the shadows, once again creating smaller shapes within the larger shapes. Don't get too carried away though—resist the temptation build up those rich darks.

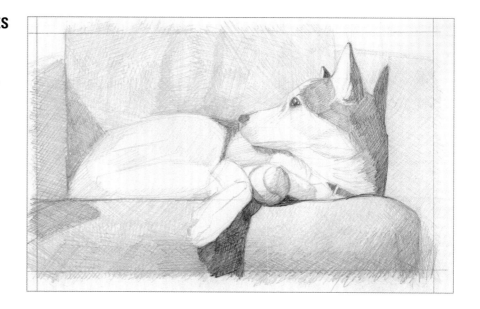

Visit artistsnetwork.com/drawrealisticanimals to download a free bonus demonstration.

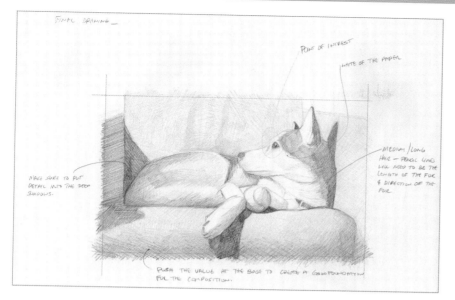

7 ADD MORE VALUE AND MAKE FINAL TWEAKS

Add a few more areas of value and a few final tweaks to finish your composition sketch. Instead of going further with details, simply make notes at this point and jot down any other compositional ideas you may have. You could continue moving forward with this drawing at this point, building up the darks and refining more and more until you have an image that you like. That is how I started out, and it's how many of my students start off. In the end it comes down to what you want your finished drawing to look like, what kind of polish you want it to have, and finding a process you are comfortable with.

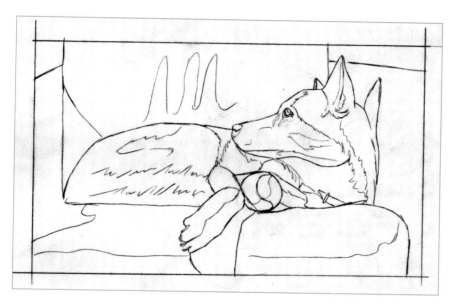

8 CREATE THE CONTOUR DRAWING

Once the composition sketch is drawn, take a piece of tracing paper and lay it on top of the sketch to trace out a contour drawing. The contour drawing is the map or blueprint of a drawing's foundation. It is OK to look at the reference as you do this to try to capture some of the detail contours as well. When finished, you should have a drawing that outlines what will be the final three-dimensional drawing. It's ready to be transferred to the final drawing surface.

FREE YOURSELF!

When I work on my sketches, I feel no pressure whatsoever because in my mind, they are just sketches and not finished products. If at any point I am not happy with something, I can simply tear it out.

If you create this same freedom for yourself, your sketches will be better and more accurate. This in turn creates the launching platform for the finished drawing, since you have a good stable foundation to start from. You can confidently move on to the actual drawing, knowing that you have already worked out the problem of finding the shapes.

Transferring a Contour Drawing

There are a few different ways you can transfer your contour drawing to your final drawing surface—the grid method, with transfer paper, or with a projector. Each method has its own upsides and drawbacks, but I have found the projector to be best for getting the result I desire. I used an opaque projector to transfer my contour drawings for all of the finished drawings in this book.

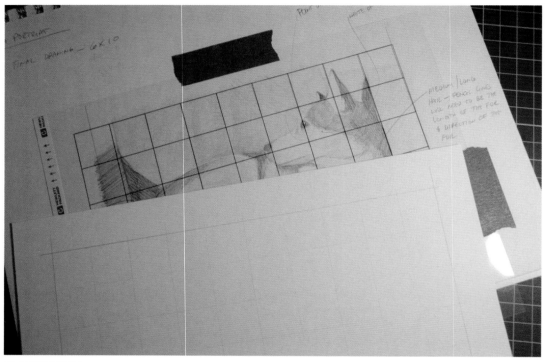

GRID METHOD

This is the most basic method of transferring a drawing and has been used for centuries. You basically have your contour drawing or reference photo overlaid with a grid made up of 1" × 1" (2.5cm × 2.5cm) blocks. The final drawing surface would also have a lightly drawn grid with an increase in the size of the blocks. For example, if a composition sketch were 3" × 6" (8cm × 15cm), and the final drawing was going to be 6" ×12" (15cm × 31cm), the grid on the final drawing paper would be 2" × 2" (5cm × 5cm). You can then proceed to draw what fills each box individually until you have the complete drawing transferred to your final surface.

ENLARGING YOUR SKETCH

You can scan a sketch into your computer, enlarge it to the size you need and then print it out. You can also use a copier to copy the image and enlarge it at the same time. Any way that you decide to enlarge your sketch is fine. The important thing is to have a printed image the same size proportionally as your final drawing is going to be.

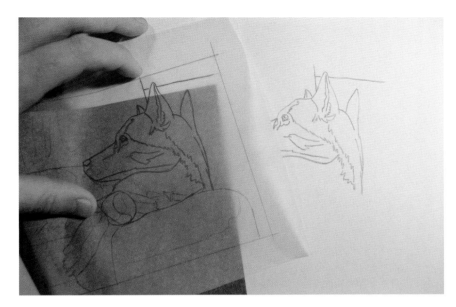

TRANSFER PAPER

There are many different transfer papers from carbon to graphite available in a range of colors. Enlarge your sketch to the size you want your finished drawing to be and line it up with your final drawing picture plane. Secure it and stick a sheet of graphite paper between your enlarged sketch and the drawing surface. Trace the contours of your sketch and in the process, the sketch is transferred onto your final surface. I have found it very useful to use a red pencil for this so that I can see what lines I have gone over already.

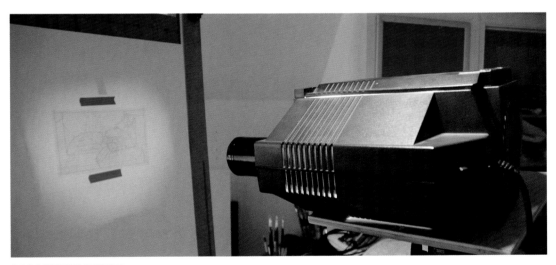

OPAQUE PROJECTOR

Transferring with a projector is simple enough. Just place your contour drawing onto the projecting surface and set your projector at the distance that you require to enlarge it to the size you want. Most projector screens are small and will require you to reduce your sketch in size so that it fits on the surface of the projector.

A WORD OF CAUTION

It can be very tempting to project your reference and just trace the outlines in order to skip the initial composition sketch all together, but that won't help you grow as an artist. The initial sketching phase is so important because you are deconstructing the subject in front of you, breaking it down into its most basic shapes. This will help you recreate it when modeling the form later, making your drawing look three-dimensional.

When we look at something to draw, there is so much visual noise that we have to edit out what is not needed. If copying straight from your reference, you will hold yourself captive to every little nuance you traced straight from the picture. And trying to copy every little detail simply isn't fun!

Part Two
Drawing Wildlife

Now that we have the fundamentals covered, we can move on to drawing some animals. Just as the fundamentals are universal and can be applied to any subject matter that you may choose to draw, so too are the drawing techniques covered in this next section. Yes we may happen to be drawing animals, but drawing itself is more of way of seeing than anything else. Look at the shapes that make up the animal, and carefully look at the textures that describe the animal. Then recreate that with the tip of your pencil.

The demonstrations in the pages that follow all focus on the techniques of drawing various textures of different species using the continuous tone method of layering graphite. To achieve these highly detailed drawings, I implore you to have patience and to accept up front that you will have some aggravation as you work. This is completely natural. It is all part of the process. Every one of these drawings took many hours to complete—there simply are no short cuts to achieving the desired solid tones in these drawings.

Gather your patience, keep aware of your internal voice without criticizing yourself, remember to ask yourself questions… and always keep your pencil sharp.

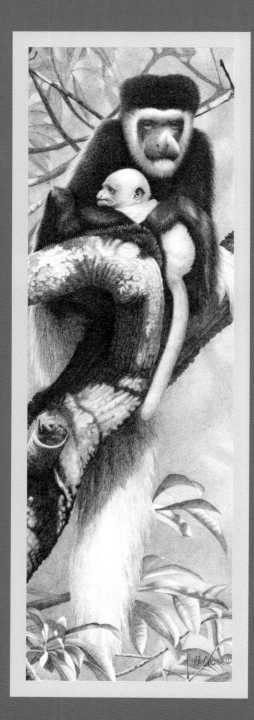

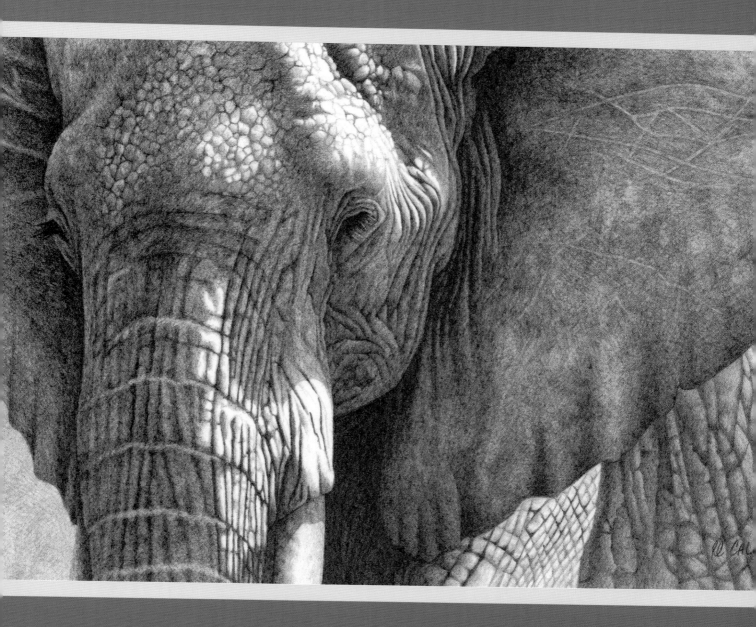

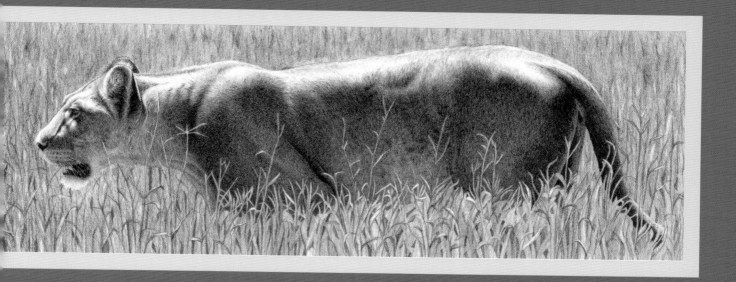

Tabby Cat

The common household cat serves as a great subject for drawing an animal with short hair. Short hair is nothing more than a visual texture that you create with your pencil marks. The key is knowing how long to make those marks and when to add them in. When beginning your drawing, focus on the general shape of the cat and not on the details of the fur. Make sure to establish the structure of the cat first.

This is a relatively simple composition. I purposely left out any details in the background so the drawing could be entirely about the cat and her intense stare.

Materials

- Arches #300 (640gsm) cold-pressed watercolor paper
- 4H, 2H, HB, 2B, 4B and 6B pencils
- kneaded eraser
- craft knife

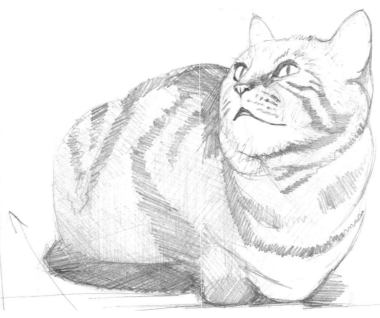

1 SKETCH AND TRANSFER
Draw a sketch capturing the basic foundation of the cat and work out any compositional ideas or problems. Don't draw everything at this point. Keep it simple. Feel free to make notes for reference. Once you have the basic structure of the cat and the major shapes are drawn in, create a contour drawing and transfer it to your drawing surface.

TIPS FOR DRAWING HAIR AND FUR

Hair or fur is basically a texture that sits on top of a structure or simple shape. Look beneath the detail and ask yourself what shape is under all of it. Once you have built the underlying structure, you can start to focus on adding details of the hair and fur.

Draw the negative shapes around the tufts of fur. If you try to draw the actual fur, you will end up covering the parts you want to show. Hair and fur are revealed when hit by the light, so focus on the shadows and shaded areas that define the outer edges of the hair and fur.

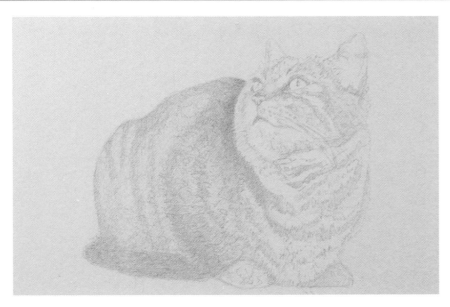

2 ADD CONTOUR LINES AND LAY IN THE BASE LAYER

Once you have transferred your sketch to your drawing surface, very lightly reestablish the contour lines. You want to avoid using your eraser, so it is important that you do not make your contour drawing too dark.

Lightly lay in the base layer of the dark stripes on the cat with a 4H pencil. This will start to build your foundation for the next layers as you establish some of the characteristics of the cat. Try not to get sucked in by the allure of the details quite yet. Save those for last.

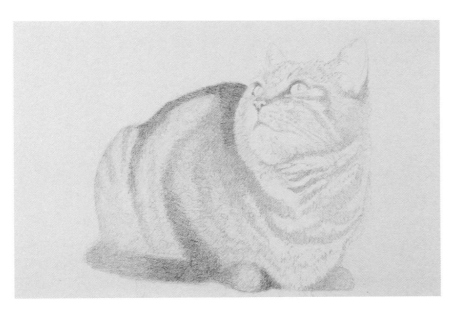

3 ADD THE NEXT LAYER AND ESTABLISH THE EYES

Go back over the base foundation layer with a 2H pencil, establishing your next layer of value. You don't want any glimpses of texture or pattern from your pencil marks at this point, so it is important that you constantly turn your paper, creating a crosshatching effect.

Continue using the 2H pencil to establish some of the hard edges and general structure of the cat's eyes. The eyes are the focal point of this drawing, so this is where you will want to have the lightest light, the darkest dark, and the hardest edge in the drawing.

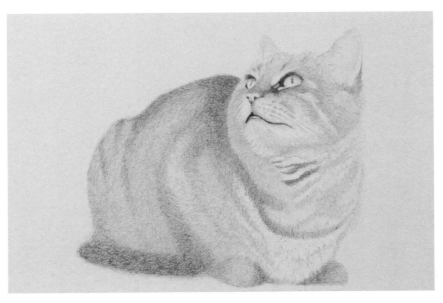

4 REDEFINE THE FACIAL STRUCTURES

With a sharpened HB pencil, go around the eyes, nose and mouth areas to redefine the structures of the cat's face. A sharp pencil is essential to keeping your lines as crisp as possible. It will also give you the most control over the pencil. Try not to press down on the pencil too hard because it will indent the paper.

5 ADD A SOLID TONAL BASE TO THE STRIPES

Still using the HB pencil, establish a good middle value on the stripes and in the shadow areas. You are looking for a good solid tonal base, and you need to keep building up that crosshatching.

The middle value layer always seems to rejuvenate my excitement about a piece because the drawing really starts to take on some of its own character through the contrast that's being built up.

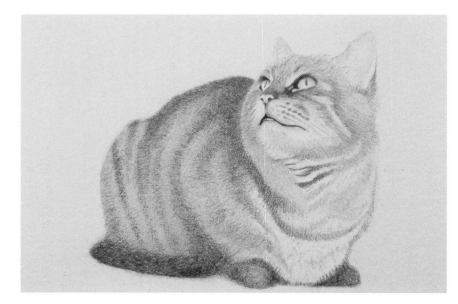

6 ADD THE NEXT LAYER AND BEGIN ADDING FUR DETAIL

Once your shadows are nicely defined, go back over the rest of the cat's body with another layer of value using the 2H pencil. Press a bit harder with this layer to darken up those areas some.

Now it's time to start bringing out the fur detail a bit. Be aware of the direction in which your pencil is moving, and pay close attention to the length of the pencil lines that you are starting to make. Create short marks on the cat's body in the direction that the fur is laying. Stop for a minute and really look at your reference. Take in how the fur is moving down along the cat's body. Move your pencil in the same direction.

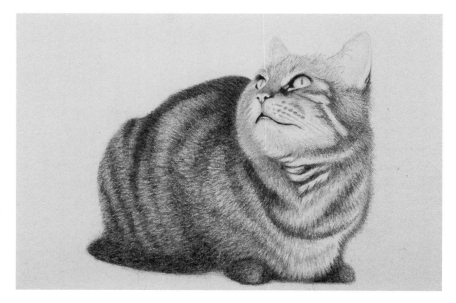

7 PUSH BACK THE DARKS

By now, your cat is really starting to come to life on the paper. Grab a 2B pencil and begin pushing the darks back. Then add a layer of 4B pencil. At this stage, it is imperative to keep your pencil sharp. You will go through your softer lead pencils faster, but what you leave on the paper will be rich deep darks.

Continue crosshatching with a 6B pencil, but pull out some short pencil lines from the dark stripes on the cat so that they look like individual pieces of hair. Remember to make them go in the same direction as the fur.

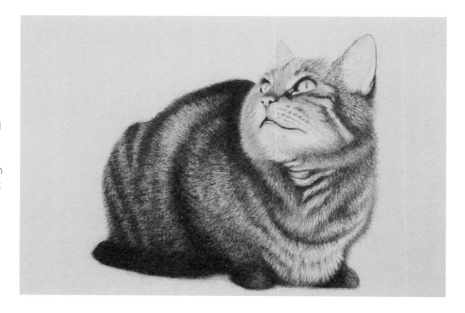

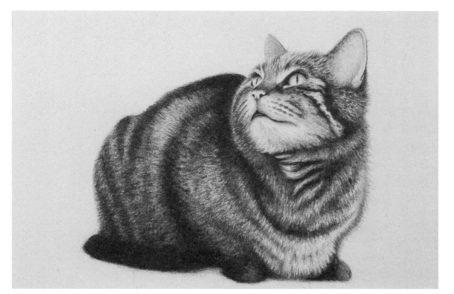

8 SHADE THE EYES AND ADD DETAILS

At this point, you have built a really strong foundation of value on the cat that supports the details of the fur. You can now go in and concentrate on the minute details, like the subtle hairs inside the ear. Look at the dark areas and draw those instead of the white fine hairs.

Work on the subtlety of the eyes as well to make them feel round. The basic shape of the eyeball is a sphere. Create the shading on each eyeball so that it describes that shape of a sphere. Because this is such a fine detail, use 4H and 2H pencils to build these values.

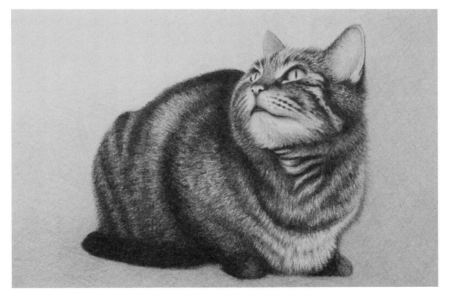

9 ADD VALUE TO THE BACKGROUND

Add some value in the background. To help emphasize the cat's stare, create a curved value change from light or mid value to the white of the paper. Darken in the right corner to make that the anchor of the piece and direct your eye to the upper left corner where the cat is looking.

Move back to your 4H pencil to start this off, creating a nice light solid base value that subtly tapers off into the white of the paper. Take your time and slowly pull back on the pressure of your hand as you move up and across the paper. The next layer will be with the 2H pencil. Do the same as you just did with the 4H pencil, but move half as far as you did with the previous layer. Again, taper it off so you don't create any harsh lines.

10 FINISH THE WHISKERS, EYELASHES AND RANDOM PIECES OF HAIR

With a very sharp 2H pencil, establish the eyelashes and random long hairs on top of the cat's head. Keep your pencil lines moving away from yourself and pull up on your pencil as you come to the end of the piece of hair you're drawing. Do this on random points of the cat's body, making sure to keep your pencil moving in the direction of the cat's fur. This will help to give the cat those final realistic touches.

Draw the whiskers using the same method that you used for drawing the eyelashes and random hairs, only this time use a craft knife. Make sure you have a fresh blade before beginning. Turn the knife upside down and use the back of the blade, not the cutting edge. Scrape off the graphite in a line to create a white whisker. You may have to go over it a couple of times to get the whiteness that you want, but don't do it too many times or you will risk going through the paper.

Visit artistsnetwork.com/drawrealisticanimals to download a free bonus demonstration.

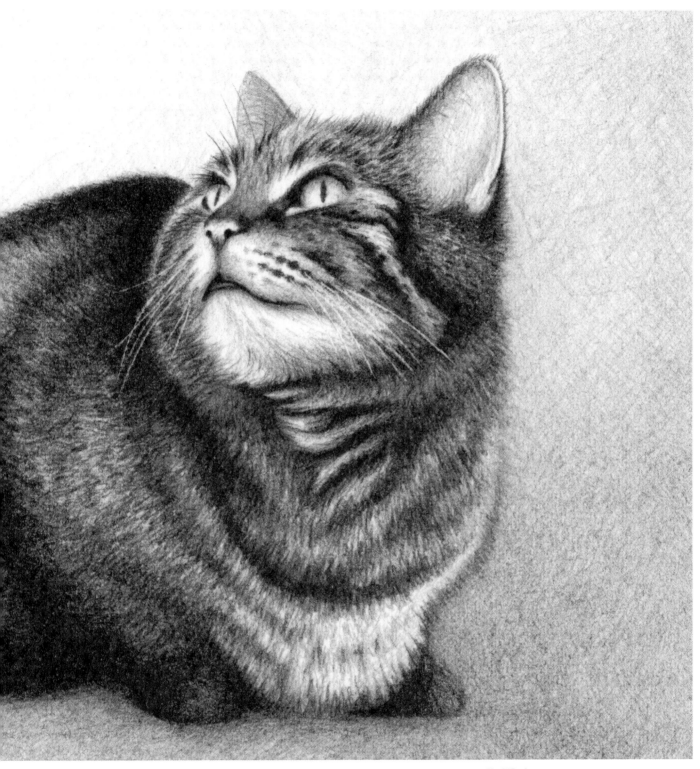

Keri (Cat)
7" × 11" (18cm × 17cm)
Graphite on Arches #300 (640gsm)
cold-pressed watercolor paper

Medium Fur

Siberian Husky

Don't overlook your family pet as a possible subject for your next drawing. Images and situations you see every day can tell a simple yet powerful story.

This drawing will follow the same process as rendering the cat with short hair. Once you have your base values established, concentrate on the direction of the dog's fur. Make your pencil marks a bit longer then you did when drawing the cat.

This piece has a background that will be laid in first, because the dog is sitting on top of the sofa. Start from the furthest area back and work your way forward.

Materials

- *Arches #300 (640gsm) cold-pressed watercolor paper*
- *4H, 2H, HB, 2B, 4B and 6B pencils*
- *craft knife*

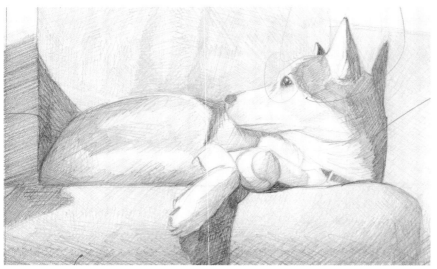

1 SKETCH AND TRANSFER
Draw only what you need to get the basic form of the dog, chair and ball. Avoid going too far with the details—save that for the actual drawing. This is only a sketch, so don't be worried about making mistakes. Embrace and work through them.

It is important to note where you want your point of interest to be so that if you get lost in the drawing later, you've got a reminder of what the plan was when you started. In this case, I also noted that some of the dog's fur would be longer than the rest of his coat in certain places.

Keep your reference photo nearby as you create your contour drawing. It will help you stay on course when composing the piece. Once you're finished, lightly transfer it to your drawing surface.

2 REDEFINE THE BASIC STRUCTURE OF THE DOG

With a 4H pencil, redefine some of the basic structure of the dog so that you don't lose him as you work on the background. Block in the eyes and nose because they are the focal point of the whole drawing.

Remember, you will have made all of your mistakes and corrections on the composition sketch, so try to resist the temptation to use an eraser.

3 ESTABLISH THE BACKGROUND

Lay in the base layer of the background with a 4H pencil. The chair is going to be dark, and you want some texture to come through. Crosshatch quickly with a bit of an aggressive quality. Be careful not to press too hard though, or you will crush the tooth of the paper.

When laying in these base foundation values, retain the general shapes that either describe the environment or subject matter. In this case, you may want to put in some temporary outlines for the chair.

4 ADD THE SECOND LAYER OF VALUE

Using a 2H pencil, start to push back the shadow areas with the second layer of value. At this point, you want to continue with just the basic crosshatching technique. Rotate your paper continually, so as not to create any unwanted patterns in the pencil markings.

5 ESTABLISH THE BASE VALUES OF THE FUR

Your background has a really good base at this point, and the chair is beginning to look like a chair. Start back to work on the dog, establishing the base value of his fur with a 4H pencil. Then add another layer of value with a 2H pencil. Fill in some of the dog's markings on its back side as well. Do not go into detail at this point, although you should pull out some directional movement of the fur on the tail because it's longer than the rest of the dog's fur.

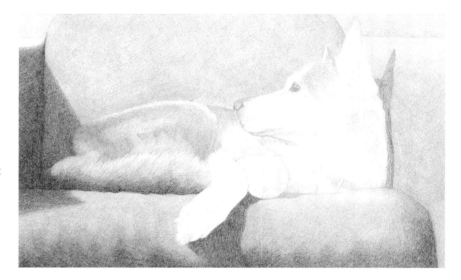

6 ESTABLISH BASE VALUES OF THE CHAIR AND ADD DETAILS

The back leg of the dog has an edge that is almost backlit. To capture it correctly, use an HB pencil to push the values behind it so that you retain the white of the paper. Go back in with a 2B pencil and start to really push the dark value in the crease on the left of the chair. This will end up being the darkest part of the drawing, and that rich deep dark will help you judge the rest of the values in the piece.

Once the chair's base value is established, you can start to bring out more subtle details, like the slight folds on the back cushion, to make it look more realistic. An HB pencil will work nicely for this.

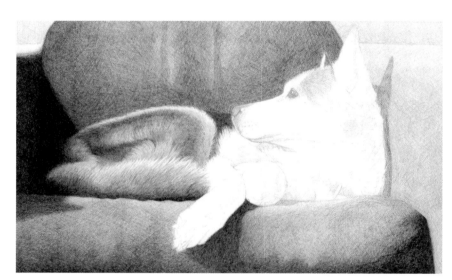

7 BUILD UP THE EYE AND NOSE

Keeping the point of interest of your drawing in mind, reestablish the dog's eye and the darker creases of the nose.

Use an HB pencil and take your time. Look closely at your reference. Ask yourself what shape you are looking at, and which direction the line is going. The questions you ask yourself greatly affect how you approach your drawing.

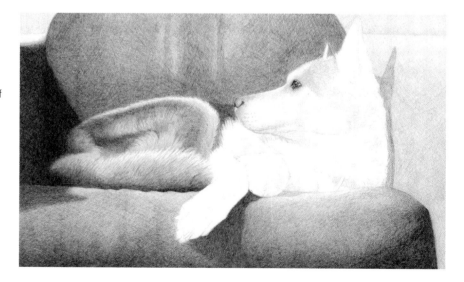

Visit artistsnetwork.com/drawrealisticanimals to download a free bonus demonstration.

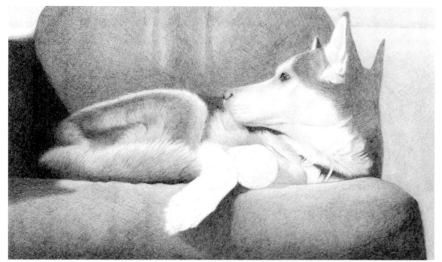

8 BUILD UP THE DOG'S HEAD AND CONTINUE ADDING VALUE

Start work on the dog's head by applying a layer with 4H pencil. Add another layer with a 2H pencil on top of that. Just continue building up value at this point—don't try to establish any detail. Switch back to a 4H pencil and fill in the darker areas of the lighted fur, then go into the white area of the fur to build up those subtle value shifts. Take your time on the lighter areas, because what you lay down at this stage are the basic finished values that you want to be left with in the end. Keeping your pencil sharp and slowing down your crosshatching is the key at this point.

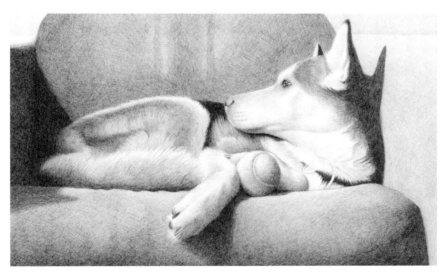

9 BUILD UP THE FOREGROUND

Once you have built up a good base of values on the head, move on to the foreground objects—the front paw and the tennis ball. The tennis ball is relatively simple because it's a sphere with a matted hair texture. The front paw is basically a cylinder turned on its side. Start in the shadow area with a 4H pencil and then add a layer with a 2H pencil on top of that. Build your core shadow area and follow the jagged edge that the underlining bones and tissue create. On that edge, start to pull out the negative shapes of the fur that create the lighter hairs. Remember to draw the negative spaces created by the lighter fur/ hair (positive shapes).

10 DARKEN THE NEGATIVE SHAPES AND ADD DETAILS TO FINISH

Darken up the negative shapes in the background so that they help pull the highlighted areas of the arm of the chair out, giving depth to the drawing. Then darken any of the shadow areas you feel may need more depth, like behind the dog's head to separate the head from the cast shadow on the arm of the chair. Use very sharp 4B and 6B pencils for those rich darks. Sometimes a 4B will seem like the darkest you can go, but working back over an area with a 6B pencil will add that richness the drawing needs and really push the contrast in a piece.

Since the hair on this dog is medium length, your pencil lines should match the length of the hair and go in the direction of the fur. With a very sharp 2H pencil, work from the dark areas into the lighter areas, creating negative spaces between the strands of lighter fur. Then use an HB pencil to darken them up as needed.

The black of the dog's nose with the white fur around it is a high contrast area, so you don't want to create a harsh line between the two. You want a nice gradual shift between the very dark nose and the white fur. Layer in 2B pencil and then 4B pencil over that. Tighten up your crosshatching at this point. The back-and-forth motion of the pencil should be only around ⅛" (0.3cm). Darken up the nostril with a very sharp 4B pencil.

Finally, reveal the whiskers the same way you did with the cat—scrape them out of the dark area with an craft knife, using the blade turned upside down.

Visit artistsnetwork.com/drawrealisticanimals to download a free bonus demonstration.

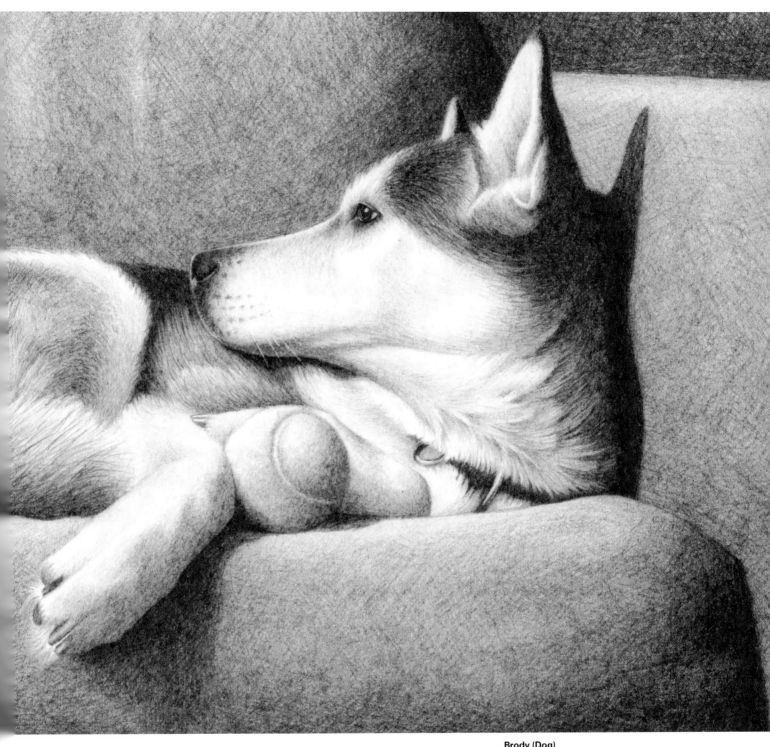

Brody (Dog)
6" × 10" (15cm × 25cm)
Graphite on Arches #300 (640gsm)
cold-pressed watercolor paper

Long Fur

Colobus Monkey

I was very fortunate to have seen this white baby Colobus contrasted with its mother's long black fur while traveling in Arusha National Park in Tanzania. I chose to make this composition long and narrow to emphasize the overall length of the monkey's tail. The tail and branch pull the eye from the lower left corner up to the focal point of the drawing—the faces of the mother and the baby monkeys.

Not only is this drawing a great piece for showing how to render long fur, it's also a great example of how to control the values of the overall drawing. You have a completely white subject in this drawing, which means you need to put a light value over the entire surface of the paper so that the baby Colobus ends up being truly white. You have to work within the limitations of your materials, and you can't get any whiter than the surface of your paper.

Materials

- *Arches #300 (640gsm) cold-pressed watercolor paper*
- *4H, 2H, H, HB, 2B, 4B and 6B pencils*

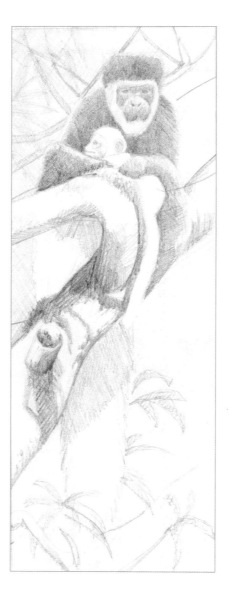

1 SKETCH AND TRANSFER

Draw your composition sketch. Work out all the shapes of the monkey and her baby, as well as the main branch and some of the basic foliage in the background.

I made the decision in this first stage to cover the entire surface of the paper with a light value in order to retain the white of the paper for the baby monkey. I also decided to make the foliage above the mother's head dense and dark to help keep the eye from wandering off the page.

Transfer your contour drawing onto your watercolor paper.

Visit artistsnetwork.com/drawrealisticanimals to download a free bonus demonstration.

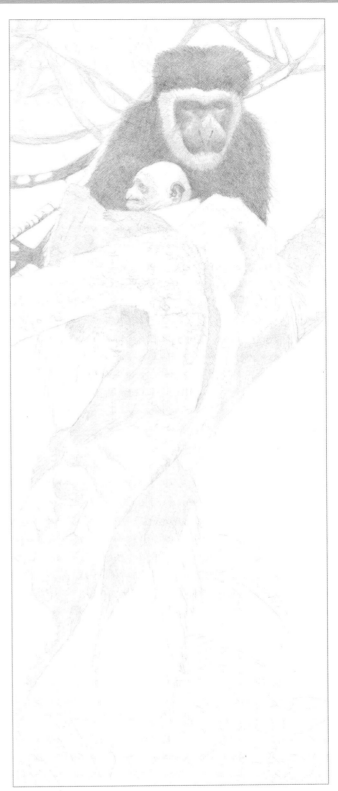

2 ESTABLISH THE BASE VALUES AND BEGIN TO STRUCTURE THE BABY'S FACE

Use a 4H pencil to establish the base value of the mother monkey. Then add a second layer with a 2H pencil. This will give you enough contrast to work on the beginning of the baby's white face. You are only looking to build structure at this point, so don't put in any detail yet. Resist the temptation to draw the baby's face to completion right away.

3 BUILD CORE SHADOWS IN THE TREE LIMBS AND THE MOTHER'S BODY

Use a 4H pencil and crosshatching to build up your base values in the core shadow areas of the small tree limbs, large tree limbs and the mother's body. Then lay in the next graphite layer with a 2H pencil. Build the branches in the upper right corner up to a good mid value using an HB pencil over the 2H pencil layer.

4 CONTINUE BUILDING VALUE AND CONTRAST

Continue working in the upper left corner, building the values in the leaf structure with a 4H base layer and a second layer of 2H graphite. Be careful with this corner though, because the long composition makes it very easy for the eye to wonder off the page.

You also want to watch the contrast of the baby's white face and the mother's dark black fur. Build two more layers of value on the mother's chest. Use an HB pencil first. Keep your pencil sharp and the crosshatching somewhat tight. The back-and-forth motion of the lines should be around ½" (1.3cm) and not have too much of a gap. Remember you want a solid tonal mass with no little white patches peaking through. Lay in the next layer the same way, using a 2B pencil. Because B pencils have a softer lead, you will find yourself constantly sharpening them.

5 ESTABLISH THE MIDDLE VALUES AND BEGIN ADDING TEXTURE AND DETAIL

Continue working on the mother, while remaining focused on keeping a high contrast between mother and baby. Work your way down the body and onto the arms with a good solid layer of 2H pencil before adding another layer with an HB pencil. Establish a good mid-value layer with the HB, using crosshatching. Turn the paper constantly so that you won't create any unwanted texture or patterns.

The monkey should be starting to get really dark and is ready for some detail and fur texture. Use a 2B pencil to create lines for fur. Don't try to draw every hair in its place, but more just the general idea and direction of the fur. Keep your pencil very sharp and draw the negative spaces around the lighter fur. You are revealing the lighter fur by drawing the shadows and darker recesses of the fur.

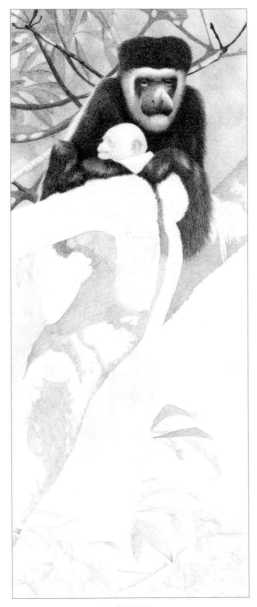

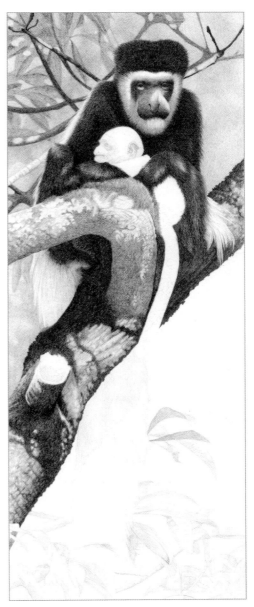

6 LAY IN THE BACKGROUND

Apply a base layer to the upper background using a 4H pencil and crosshatching. Keep the motion of the pencil relatively tight at about ½"–¾" lines (1.3cm-2cm). Add a second layer of value with a 2H pencil using the same technique. Keep an eye on the leaves and branches you've already drawn so they don't get lost as you block in this overall value in the background.

Darken up the leaves a bit with a third layer of value using an HB pencil. Do not add any detail because you want to make them recede, not pull them forward.

With an HB pencil and light pressure, add a third layer of value on the upper background. Keep your crosshatching smooth and tight. Go into the background distant foliage with a bit more pressure. The shapes need to be in the general form of a leaf but with no distinctive outline and absolutely no detail.

7 BUILD UP THE TREE TRUNK

Finish establishing the base value of the shadowed areas with a 4H pencil. Add a second layer with a 2H pencil using crosshatching. Then start to pull out the grooves of the tree bark, one at a time. Look at where each groove starts and where it ends; which side is in shadow and which side has light. After you get the base layers down, switch to an HB pencil and follow what you've already laid down, just darkening up and working into the grooves of the bark. The length of your crosshatching lines should be getting much smaller, down to ⅛"-¼" (0.3cm-0.6cm). The amount of pressure you apply will determine the amount of graphite that comes off of your pencil.

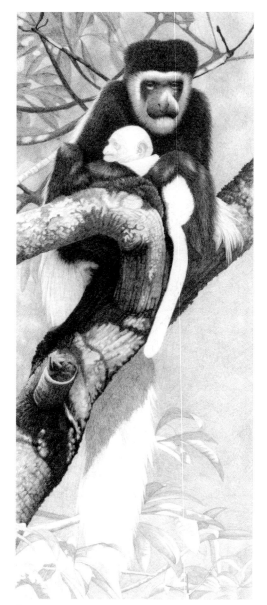

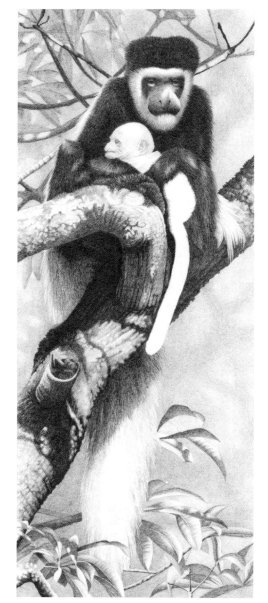

8 BUILD UP THE BRANCH AND BACKGROUND

Build up the branch in front of the monkeys with the same approach you used on the main tree trunk. The grooves of the branch run parallel to the direction the tree is growing. There are also some creases in the bark where the limb folds back onto itself. Draw these in as you did the others, but going against the grain.

Build up the base layers on the patch of moss with 4H and 2H pencils. Lay in a third layer with an HB pencil, moving from cross-hatching to more of a scribbling motion. Add fourth and fifth layers of value using 2B and 4B pencils, continuing scribbling. Draw in the negative spaces left behind by the highlighted areas of the moss.

Block in the base layers of the background below the branch in the same way as the upper portion of the background. Apply the first two layers with 4H and 2H pencils. Pull some of the back-ground value up into the negative spaces in between the long hairs of the mother's tail. Start to build darker values in the foreground leaves at the bottom. Add details that make them identifiable as leaves, but keep them blurry.

9 FINISH THE BACKGROUND AND TAIL

With a sharp HB pencil and light pressure, establish a light third layer of value on the lower background to bring out the distant blurred pieces of foliage. Complete the foreground leaves at the bottom of the drawing with a sharp HB pencil. Use a 2B pencil to fill in the dark areas on the leaves and small branch on the far left.

Use a 4H pencil along the sides of the mother's tail to build a very subtle base value that tapers off as it comes to the center on each side. You want to give the impression of roundness and leave the white of the paper at the center to show that the tail is white. With a sharp 2H pencil, start to bring out the characteristics of the long fur. Keep your pencil lines long. On the outer edge of the tail, pull your lines in from the negative areas you filled in earlier. Allow the lines to taper off as if they're getting lost amongst the other hairs of the tail.

Finish off the tail by revisiting the cast shadow under the branch and darkening up some of the negative areas of the hair as it gets closer to the limb. Pull out random dark hairs on the edge of both sides of the tail in the shadow area to give it a realistic look.

Visit artistsnetwork.com/drawrealisticanimals to download a free bonus demonstration.

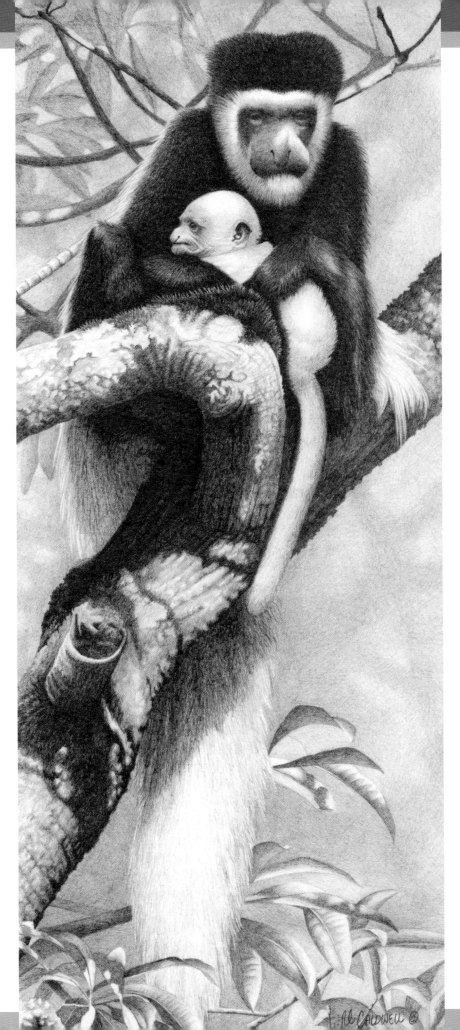

10 FINISH THE BABY AND ADD FINAL DETAILS

Lay in the base value for the areas of the baby in shadow with a 4H pencil. Start off with crosshatching but also begin to build texture by making your pencil lines in the direction of the fur. Keep these lines short, as you did when drawing the tabby cat.

Use a 4H pencil to give the baby's tail the same round feeling as the mother's tail.

Establish the final shadow areas on the baby with a 2H pencil. Keep your pencil lines short and in the direction of the fur, but don't make them very distinctive. The fur is white and short, so we shouldn't see too much detail.

The skin of the baby's face and the ear needs to be a bit darker then the shadowed areas of the white fur. Add another layer with an H pencil using very light pressure. Bring out some of the subtle creases in the face and underlying bone structure. Look at the shapes they make and not what they are. With very sharp HB and 2B pencils, darken up the iris of the eye, the nostril, the mouth line and the inner ear.

Push the darks in certain areas as needed with a 6B pencil.

KutoKua Na Hatia (Colobus Monkey)
11" × 7" (28cm × 18cm)
Graphite on Arches #300 (640gsm)
cold-pressed watercolor paper

Selected for Art and the Animal Society
of Animal Artists 53rd Annual Exhibition,
Bennington Center for the Arts,
Bennington, Vermont

Fork-Tailed Drongo

Birds are great subject matter because they can be found pretty much anywhere and easily studied without too much expense. A simple bird feeder in your backyard can serve as a platform for a variety of future drawings.

The bird in this drawing is a fork-tailed Drongo, which I photographed while on safari in Tarangire National Park in Tanzania, Africa.

Materials

- *Arches #300 (640gsm) cold-pressed watercolor paper*
- *4H, 2H, HB, 2B, 4B and 6B pencils*

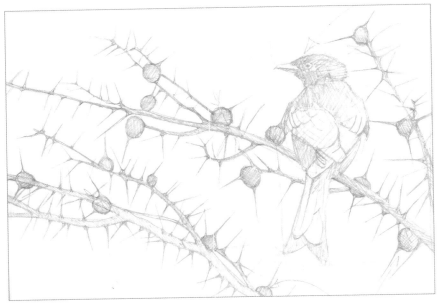

1 SKETCH AND TRANSFER

Sketch your composition in your sketchbook. Since the bird is so dark, make sure to draw out the feather structure—especially on the tail because it is a dominant feature in this particular species of bird. Make note of the bird's very pointy, almost hooked bill. These types of details are essential to identify and carry over into your drawing. They can be attained simply by doing some research about the particular animal you are drawing.

Once you have your composition worked out, create a contour drawing and transfer it to your final drawing surface.

TIPS FOR DRAWING FEATHERS & SCALES

From a drawing standpoint, feathers and scales are much the same as fur—surface texture on top of simple shapes. Like fur, they also move down along the body from the head towards the tail, overlapping one another.

I usually approach drawing a bird by starting with the tail feathers and moving my way up the body towards the head, then back down the wings. This aids me in creating a realistic layered effect of feathers. It is also very effective when drawing reptiles.

Since feathers and scales are layered, look for which side casts a shadow and which side is in the light. This is much easier done with wing feathers and larger scales than body feathers and smaller scales. In fact, sometimes with body feathers and small scale areas, it is better to just rely on the animal's body shape rather than the individual feathers or scales.

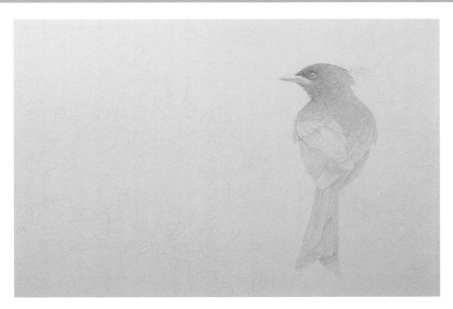

2 STRUCTURE THE EYE AND LAY IN INITIAL VALUE LAYERS

Firm up the eye structure with layers of 4H and 2H pencil. Do just enough to make the eye identifiable as an eye.

Build the first layer of value with crosshatching and a 4H pencil. Keep your pencil lines about ½"(1.3cm) apart. The background will be pure white, so stay within the contour lines of the bird. Start the second layer of value on the bird's head using a 2H pencil.

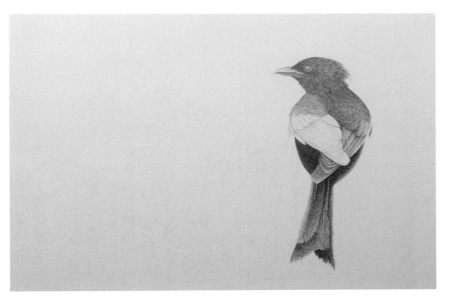

3 BUILD VALUE ON THE LOWER BODY

Move down to the lower portion of the bird's body and tail feathers and continue building value with a 4H pencil followed by a 2H pencil. This portion of the bird's body is almost pure black—use that dark value to judge the other parts of the bird as the drawing progresses.

With a very sharp HB pencil, begin building the third layer of value, pushing back the darkness of the bird's lower body and the back tail feather. As you build up this layer, work around the shafts of the tail feathers (the light strip in the center of each feather) to retain their lighter values.

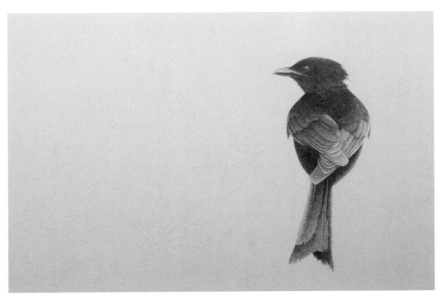

4 BUILD UP THE WINGS

Wing feathers overlap, and they can be broken down into manageable shapes within shapes. The primary and secondary feathers are usually the longest and largest. The secondary feathers, or coverts, get smaller and smaller as they become part of the body feathers.

Use a 4H pencil to lay the first layer onto the wings. Use crosshatching and keep your pencil sharp. Keep your back-and-forth lines to about ½" (1.3cm), which will give you more control over the smaller shapes in the wing feathers.

Add a second layer with a 2H pencil and then begin the third layer with an HB pencil.

5 REFINE THE BIRD AND DARKEN THE FEATHERS

Bring the bird to an almost-finished point, reserving the final details for last. Don't go as dark in the overall values of the right wing, because that is the direction of the light source.

Finish establishing the base value with a 2H pencil, then darken up the edges of all the overlapping feathers with a very sharp HB pencil. Use scribbling rather than crosshatching in these small areas. Vary the amount of pressure you apply to your pencil.

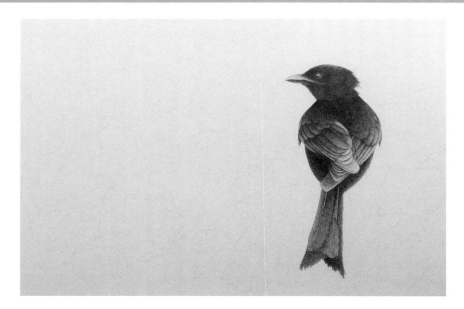

6 FINISH THE TAIL FEATHERS AND BEGIN THE BRANCH

Build another layer of value on the tail by crosshatching with an HB pencil. Pay attention to the edges of the tail. With a sharp 2B pencil, lay in the dark areas of the tail. Use very tight crosshatching and scribbling. Continue the scribbling with a 4B pencil to really push back the darkest edges that recede as each feather overlaps another.

With a 4H pencil, start to establish the base value in the core shadows of the branches, thorns and galls. Keep the light source in mind at all times. This will help you keep the shadows on the proper side of the shapes you draw. Stay within the contour lines of the branches, because the background will stay the white of the paper.

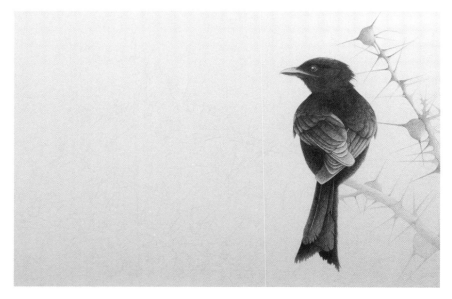

7 BUILD UP THE BRANCHES

Continue with the 4H pencil and use crosshatching on the galls and thicker branch limbs. Use scribbling in the tiny areas like the thorns. A sharp pencil is crucial. You can now switch to a 2H pencil and begin to build the second layer as you did the first.

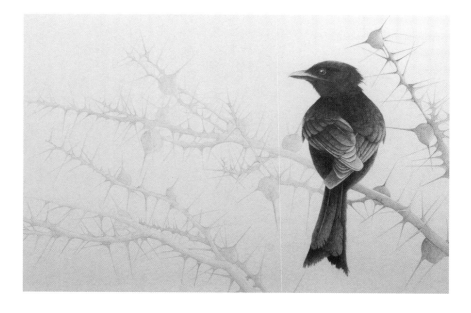

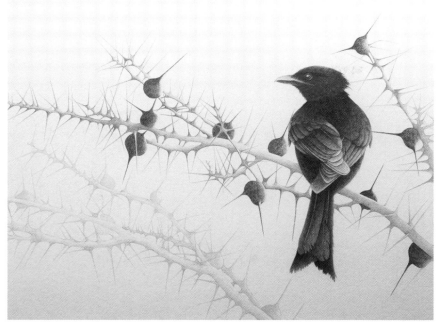

8 CONTINUE BUILDING VALUE

With the second layer of value starting to build on the galls, you should be getting a feel for the repetition of the dark values in this piece.

Continue building value along the top two limbs using scribbling and a 2H pencil. Do this more with hand pressure than overlapping of pencil lines.

Build up the galls with crosshatching and an HB pencil. Be mindful of the direction of the light source, paying close attention to where the thorn meets the gall and how the light plays off of it.

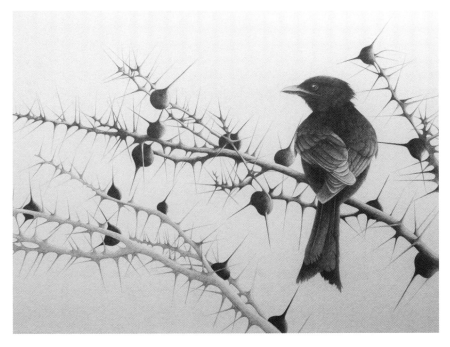

9 FINISH DETAILING THE BRANCHES

Finish the two upper limbs with an HB pencil. Use scribbling and press hard with your pencil to achieve a darker value than you would with crosshatching. This works well on small areas but is not recommended for covering large areas, as you might crush the tooth of the paper.

Complete the galls with another layer of value using the 2B pencil. Then add a layer of 4B pencil in the really dark areas.

To finish the thorns, treat them like the whiskers the tabby cat, turning the paper so that you can start the line closer to yourself, pulling out and away from your body.

10 DARKEN THE HEAD TO FINISH

Finish off the lower branches in the same manner as the others. Now that the drawing is basically finished and you can clearly see all the values in the piece, make some judgment calls on the values of the bird. The fork-tailed Drongo's head is very dark, so go back into that area and push the values back some more. Stick with a 2B pencil, very sharp, and build and darken up another layer of value. Finally, grab a 4B pencil and work on the super dark areas around the eye and under the bill.

This composition should result in a well balanced use of a really dark subject and a stark white background.

Push the darks in certain areas as needed with a 6B pencil.

Whistling Fork (Fork-Tailed Drongo)
9" × 12" (23cm × 30cm)
Graphite on Arches #300 (640gsm)
cold-pressed watercolor paper

Visit artistsnetwork.com/drawrealisticanimals to download a free bonus demonstration.

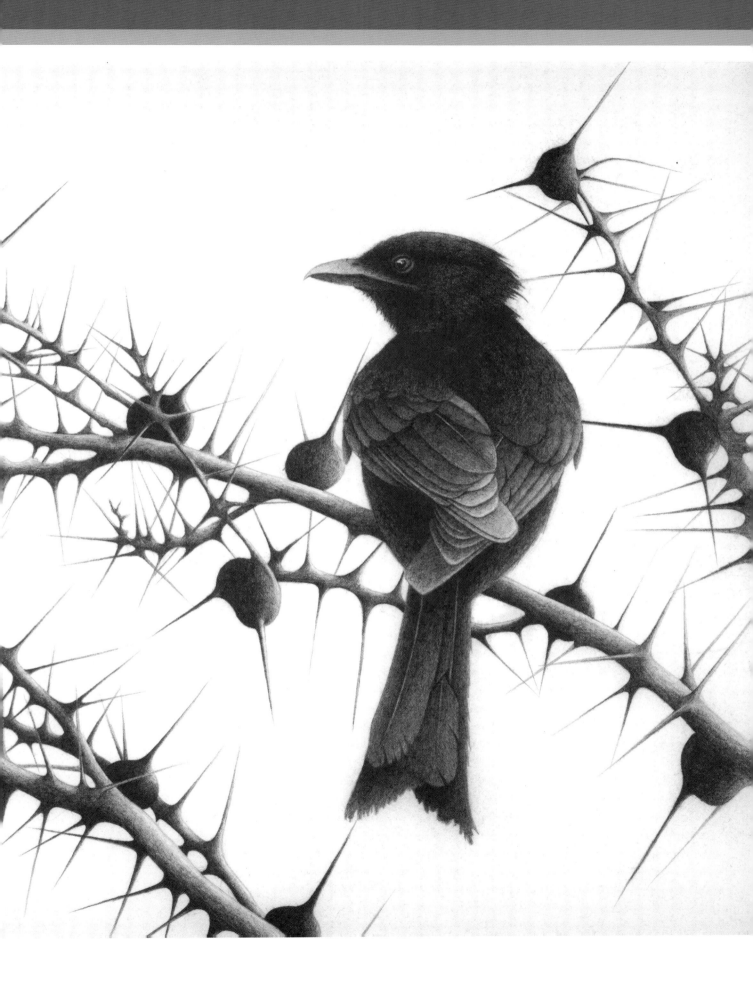

Receive bonus materials when you sign up for our free newsletter at artistsnetwork.com.

65

Rüppell's Vulture

The scene in front of me was just so dreary—the overcast skies, the dead tree and of course, the vulture all seem to really work together.

This is a challenging piece to draw but well worth the reward at the end. When drawing something this complex with all the different markings on the feathers, spend a good amount of time looking at the reference to get a sense of what is happening structure wise. The bulk of what you see in this drawing is the vulture's right wing, a cylinder shape. The feathers rotate out and along the cylinder's edge and get longer as they fall towards the secondary feathers of the wing.

Look for a pattern to use as a base to establish seemingly random markings. The feathers pretty much conform to an orderly scalloped row. You can almost follow the line of each row. Ask yourself whether a row gets smaller or wider in the direction it's going.

Materials

- *Arches #300 (640gsm) cold-pressed watercolor paper*
- *4H, 2H, HB, 2B, 4B and 6B pencils*
- *kneaded eraser*
- *craft knife*

1 SKETCH AND TRANSFER

The reference photo for this piece was practically perfect. The dead tree limb to the right was much closer to the vulture in my reference, actually almost touching the bill. I pulled it out and to the right to give enough room for the eye to enter in through the top and around the bird.

What I really like about this composition are the large areas of positive and negative shapes, which help bring out the starkness of this particular scene.

At the time this drawing was started, I still hadn't made up my mind if I wanted to put a value in the background or not. My thought was that I wanted the white parts of the feathers to really come off the paper. To do that, you need to push the value on the entire surface of the paper back.

Once you figure out your composition, transfer it to your drawing surface.

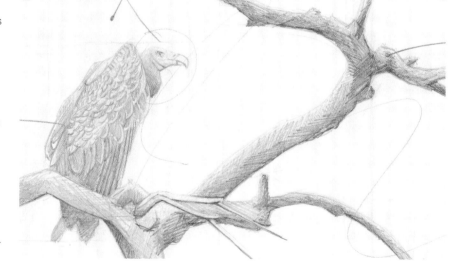

2 ESTABLISH THE HEAD AND LAY IN BASE VALUES

Begin with the focal point of the drawing: the eye and head of the vulture. Establish the base value with a 4H pencil. Use crosshatching and move down along the more easily identifiable shapes of the wing feathers. With a 2H pencil, start to build the second layer of value in the shadow areas. Define some of the edges of the feathers in the wing and folds in the skin on the neck.

3 ESTABLISH DARK AREAS AND LAY IN THE TREE LIMBS

Continue building value up the back of the vulture with a 4H pencil. Layer on top of that with a 2H pencil. All you want to do is establish the dark areas in the feathers, the markings, and find that pattern. Draw in the larger areas with crosshatching and build up the smaller areas with scribbling. Keep your hand pressure light.

Start on the dead tree limbs, establishing the base layer of value with a 4H pencil and crosshatching. Start building the second layer with a 2H pencil going all the way up the tree limb. Leave the foreground tree limb until later.

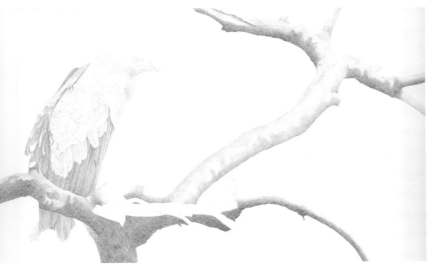

4 DARKEN THE SHADOW AREAS AND REFINE THE FEATHERS

Using crosshatching and an HB pencil, go into the darker areas of the tree limb. Keep your lines tight. Begin another layer of value with a 2B pencil in the darker shadows of the tree limb. Tighten up on your crosshatching so that you don't create any unwanted textures.

Focus back on the vulture with an HB pencil. Stick with the easily identifiable feathers on the wing and the larger areas going up the crease on the back. You are building the next layer at this point but also redefining some of the feather edges. Be careful not to make them too dark.

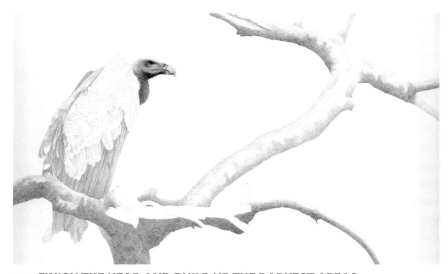

5 FINISH THE HEAD AND BUILD UP THE DARKEST AREAS

Finish the head with a second value layer using crosshatching with a 2H pencil. Keep the lines very tight. Redefine the lines in the fold of the neck as you build up the values in that area.

With an HB pencil, add a strong third layer of value creating shadows under the bill and in the recess of the eye. Work on the folds and wrinkles in the face. Make note of which side of the fold is light and which side is in shadow. Start from the shadow side and use scribbling to gently bring the shadows up towards the lighted sides. Each of these folds is like a mini cylinder.

Push the real darks under the bill in the deep shadows around the eye and in that deepest part of the groove in the wrinkles with a 2B pencil. Scribble with an increased pressure to set those rich dark areas.

6 DEEPEN THE SHADOWS AND PULL THE LIGHTER AREAS

Build another layer of value on the wing feathers with a 2B pencil. Deepen the edges and shadow areas as needed.

Use an HB pencil to pull the lighter areas of the feathers to bring the value right up next to the value you established with the 2B pencil. This is very subtle but gives depth to the shadows.

With a sharp 4B pencil, darken up the areas of the shadows going up the back where the feathers recede under the grouping of feathers you haven't really started building up yet. Darken the crease of feathers that separates the right wing from the bird's back.

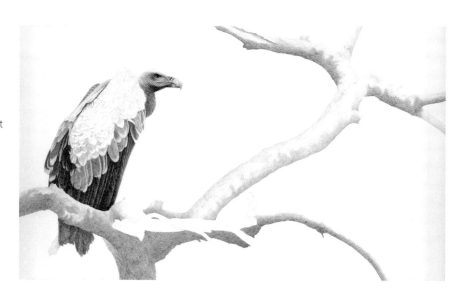

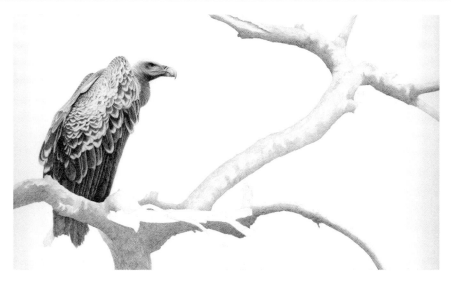

7 WORK ON THE WING DETAILS

Build up the dark spots on the right wing with an HB pencil. Work one spot a time, using scribbling and light pencil pressure. Then build a base value over the entire wing section with a 4H pencil. Don't create any textures with this layer of graphite, just add value.

Bring a subtle value change from the base of this feather area up towards the top of the back with a 2H pencil. Go back and visit each feather individually, emphasizing where they overlap.

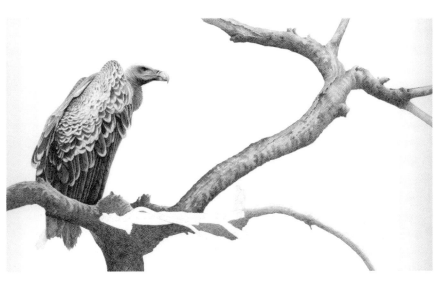

8 BUILD UP THE BACKGROUND TREE LIMBS

Go back into the light areas of the tree limbs with an HB pencil and strengthen the middle values. Redefine the smaller shapes so as not to lose them. Use crosshatching and a sharp 2B pencil to build up the values in the shadow areas and the unique shapes of the dead tree limbs. Remember to keep your lines very tight.

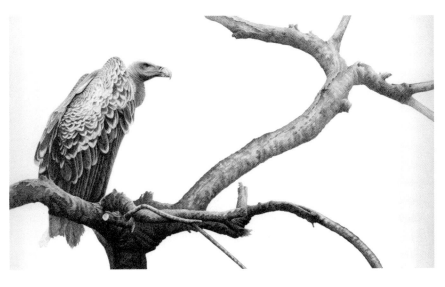

9 BUILD UP THE FOREGROUND TREE LIMB

Build up the values of the foreground tree limb in the same manner as the background limbs. Go into the shadow areas on the main tree limb and bring them to life by pushing the deep darks back some more. With a sharp 4B pencil, scribble along the dark edges of the shadows and build those up with a final layer of value. These deep darks will separate some of the forms in the shadow areas so that you can see the individual parts of the branches and feel the deep creases of the limbs turning back on themselves.

10 FINISH THE TAIL FEATHERS AND NECK

To finish off the ragged tail feathers, build another layer of value with a 2B pencil. Make sure to redefine the edges so they don't get lost. Use an HB pencil to even out the tones and bring the value of the light area right up to the value you established with the 2B pencil.

Push the deep shadows of the tail feathers with a 4B pencil. In the area where the feathers are close to the tree limb, use a 6B pencil for the final push of a deep dark value. Finish off the little branches behind the tail with the same method you used on the tail feathers.

Use a craft knife to get the white puffs of feathers on the neck. You only get one chance at this so before you start, really look at your reference one more time. Make a mental note of where those white puffs originate from and in what direction they are going. Place the back of the knife blade to the paper and put the edge of the tip at the point you want to start the scrape. Push the knife out and away from you, only going the distance that you require for the mark. In this case, it's not very far because you are creating the puff of a feather.

Finished! A seemingly difficult task has been accomplished with ease by breaking the more challenging sections down into manageable pieces and looking for some underlying patterns amongst the chaos in a highly marked subject matter.

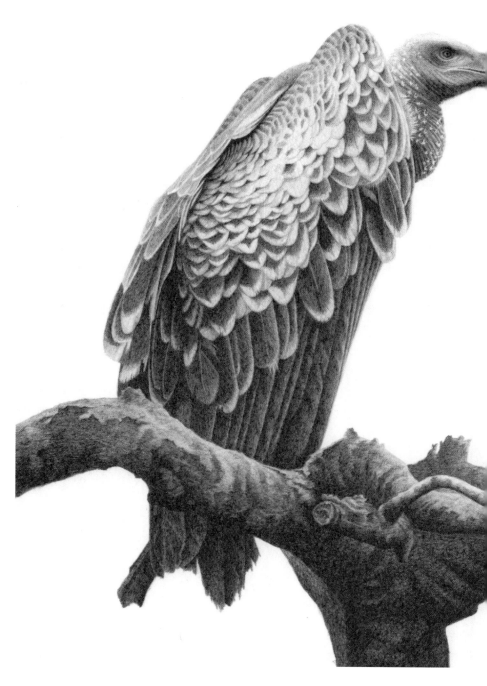

Custodian (Rüppell's Vulture)
Graphite on Arches #300 (640gsm) cold-pressed
watercolor paper, 10" × 17" (25cm × 43cm)

Private Collection
Selected for Birds in Art 2013 Museum Exhibition,
Leigh Yawkey Woodson Art Museum, Wausau, Wisconsin

Visit artistsnetwork.com/drawrealisticanimals to download a free bonus demonstration.

Receive bonus materials when you sign up for our free newsletter at artistsnetwork.com.

71

Red-Headed Agama

This drawing is all about textures. The play of the patterned scales against the roughly grained tree limb was something I couldn't resist drawing. The composition also has a high contrast between the positive and negative shapes, which makes the tree limb and lizard pop off of the page against the relatively dark background.

Drawing scales can seem daunting, but it is actually an easily approachable task. Scales are almost architectural in a sense; they follow a distinctive pattern, a sort of grid system. That is the way I approached drawing the scales on this red-headed Agama. The main thing to remember is that it's not a flat architectural element, but a surface that curves and takes the grid system with it.

Materials

- *Arches #300 (640gsm) cold-pressed watercolor paper*
- *4H, 2H, HB, 2B, 4B and 6B pencils*
- *kneaded eraser*

1 SKETCH AND TRANSFER

All you want to capture in this composition sketch are the major shapes of the lizard and the dead branch it is sitting on. Since the head of the Agama is the focal point, spend some more time sketching that out to ensure that everything is accurate. Make sure the eye, ear and nostril are all in the right spots. Do not spend too much time trying to draw the actual scales yet because it would be tedious to try to transfer those. (In my notes, I prepared for the amount of work it would take to draw all the scales on this guy.)

Create a contour drawing from your composition sketch and transfer it to your final drawing surface.

2 PULL OUT THE WOOD GRAIN, LAY IN THE BASE VALUE AND DEFINE THE EYE

Start with a 4H pencil. Spend some time pulling out the directional movement of the gnarled wood grain in the background. It will play a major part in the drawing in the end, creating movement from the bottom of the picture plane up to the lizard's head. Don't push the detail and contrast too much on the upper portion of the branch, however. This will help to keep the eye in the drawing.

With a 4H pencil, build up the first layer of value in the core shadow areas of the lizard. The body shape is that of a cylinder, so keep that in the back of your mind as you draw. Define the eye area and some of the structure on the head to give the drawing a strong anchor point from which to work.

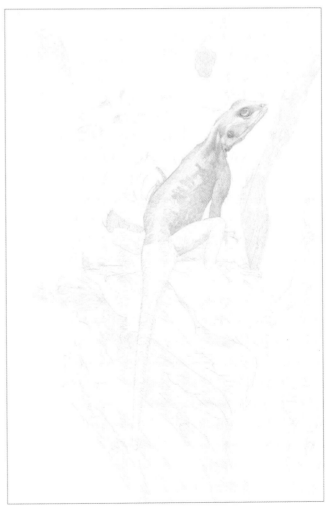

3 CONTINUE BUILDING VALUES AND FIGURE OUT SCALE PATTERN AND PLACEMENT

Continue building the base value on the upper part of the lizard's body with a 4H pencil using crosshatching. Keep your lines no longer than ½"(1.3cm) because you're not working in a very large area. With a 2H pencil, start to add another layer of value in the shadow areas. At this point, you are just starting to get the idea of where the scales will be.

To start to get a sense of the placement, use spatial measurement, drawing an imaginary line from the bottom of where the legs join the body and across the base of the neck, in the direction that the spine is going. Make a mental note of the distance and then cut it in half. Then cut those two halves in half, and so on. Keep this mental layout superimposed on top of the lizard's back to help place the pattern of the scales.

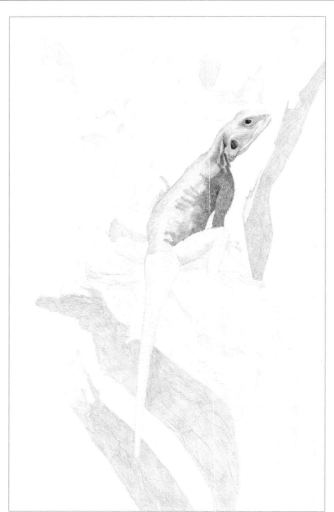

4 BUILD UP THE FACE AND LAY IN THE BACKGROUND VALUE

Use a sharp HB pencil to push the values in the eye, ear and folds of the neck so that they look about two-thirds of the way finished. Because the area is so small, use scribbling and remember to watch your hand pressure.

Now that you have a good sense of the lizard's form, start to build values in the background. Lay in the background base value by crosshatching with a 4H pencil.

5 DARKEN THE BACKGROUND

The background in the drawing is important because of its dark values. Push the entire background back so that it helps the lizard and branch pop off of the paper. At this point, you have already built up your first layers of value with 4H, 2H and HB pencils. Now that you have a good solid tonal mass just above the midpoint of the value scale, go in with a sharp 2B pencil and create some odd random shapes to break up the larger negative shapes of the background. (I call this creating visual texture.) You want to create a dance of value in the negative areas— just enough movement to pull the viewer in, but not enough to completely miss the main focus of the drawing. There is no right or wrong at this point, so have fun!

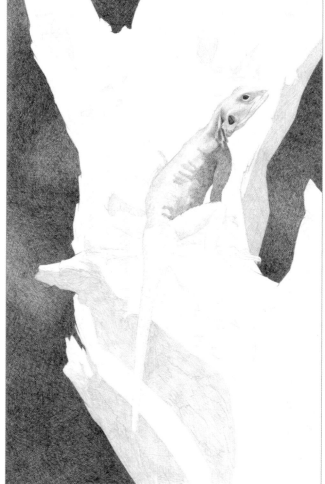

Visit artistsnetwork.com/drawrealisticanimals to download a free bonus demonstration.

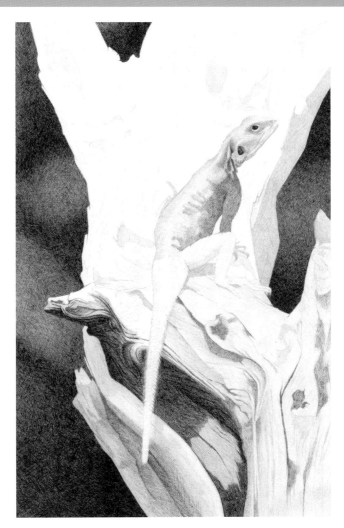

6 FINISH THE BACKGROUND AND BEGIN DEFINING THE WOOD

Finish the background with a final layer of 4B pencil. Establish a light base value on the lower half of the tree with a 4H pencil, retaining the edges of the wood that catch the light. Push the light value just enough so that you can see a distinct value difference between the lighter value and the white of the paper. Define the wood grain texture with a 2H pencil. Add another layer of value in the shadow area under the tail and start to define the wood grain in that area with an HB pencil.

7 CONTINUE BUILDING UP THE BRANCH AND WOOD GRAIN

Continue building up the branch with very subtle value shifts from area to area. Switch between a 4H and 2H pencil for this, as well as shifting between crosshatching and scribbling. Don't let the complexity of the wood grain bog you down. A sense of the direction of the grain will be fine.

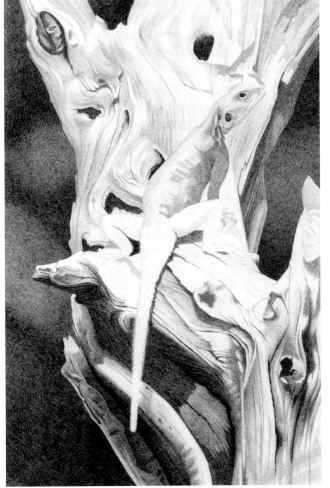

8 BEGIN THE SCALES

Begin to draw in a grid of scales. Remember that the basic shape of the lizard is a cylinder, so the grid will be curved as it moves around the body. Don't worry too much at this point about making them looking like scales; just get the correct placement. Use a sharp 2H pencil and light pressure.

Create the base value in the tail with a 4H pencil and crosshatching. Then use a 2H pencil to start defining some slightly shadowed scales on the tail. The scales along the tail overlap each other starting at the end of the tail and progressing up the body. The preceding scale will always have a cast shadow on it created by the scale above it. The cast shadow is a soft edge, a value that shifts from a darker value to a lighter value. The hard edge of the scale on top abruptly stops, creating the edge of the scale.

This area of the tail is very small and the scales are even smaller, so use scribbling to build the value and forms of the tail.

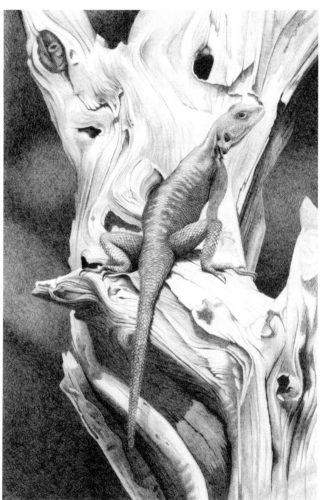

9 FINISH BLOCKING IN THE SCALES AND DARKEN THE SHADOW AREAS

By now you should have established a grid pattern over all of the lizard, keeping in mind the whole time that all the parts of this little guy are made up of cylinders going in different directions. Simply follow the form to establish the grid (scales) along the back, legs, tail and feet.

Once you have the grid representing the scales, it is just a matter of going in with an HB pencil and darkening up some of the lines, such as the scales that are in shadow or those that come together to create a crease in the skin. Create the slight cast shadows on the scales of the back legs in the same way as you did the tail. Switch back and forth between HB and 2B pencils when working on these areas.

Darken up the shadows under the rear legs with a sharp HB pencil and then a layer of sharp 2B pencil. Create both layers of value with scribbling. This technique along with a sharp pencil point will create a nice solid tone in your shadows.

10 BUILD AND TWEAK THE SHADOW VALUES TO FINISH

Darken up the front leg that is in shadow. Take care not to lose the grids representing the scales. Add a really good solid layer of value by scribbling with an HB pencil. Once you have a solid shadow value, use a 2B pencil to create the dark edges of the scales and the deep dark shadow areas of the front leg.

Tweak some of the shadow areas on the branch. Finish building up the values in the shadow areas with an HB pencil. Then use 2B and 4B pencils as needed for the deep dark creases of the branch.

Kikoti Askari Siku (Red-Headed Agama)
11" × 7" (28cm × 18cm)
Graphite on Arches #300 (640gsm)
cold-pressed watercolor paper

Visit artistsnetwork.com/drawrealisticanimals to download a free bonus demonstration.

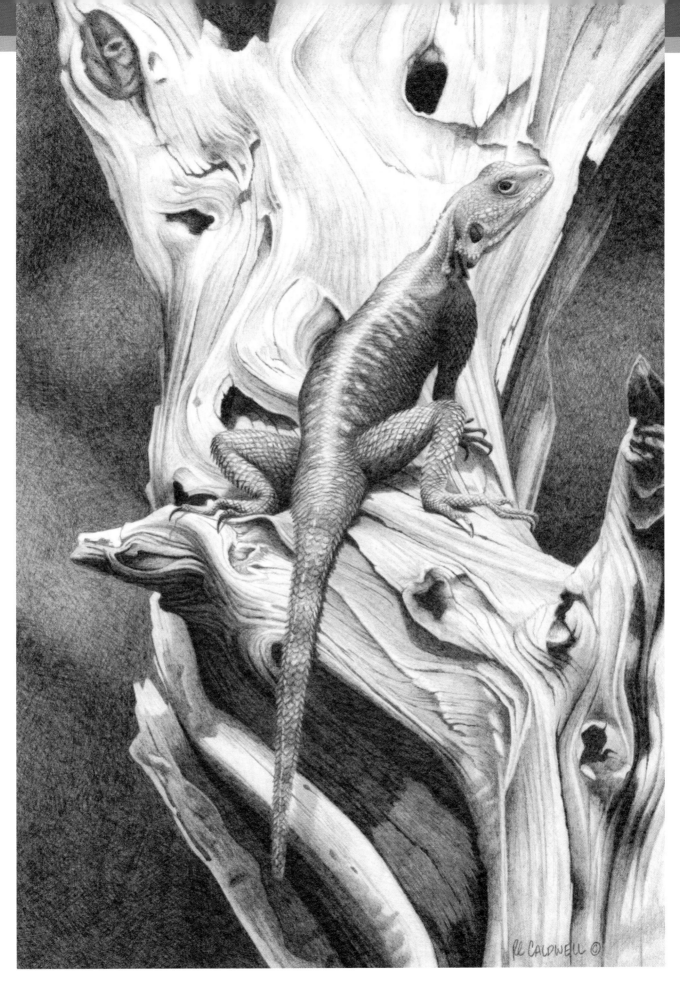

rl CALDWELL ©

Receive bonus materials when you sign up for our free newsletter at artistsnetwork.com.

77

Skin

African Elephant

Skin can have so many characteristics from wrinkled to severely taut. In this one subject of an elephant, there is a vast array of textures, from the heavily wrinkled trunk and dried mud on the forehead, to the smooth stretched skin of the ear. These different areas of texture can also be used as compositional elements. The large simple surface of the ear is a nice resting area for the eye and balances the aggressive vertical high-contrast texture of the trunk.

Materials

- *Arches #300 (640gsm) cold-pressed watercolor paper*
- *4H, 2H, HB, 2B, 4B and 6B pencils*
- *craft knife*
- *kneaded eraser*

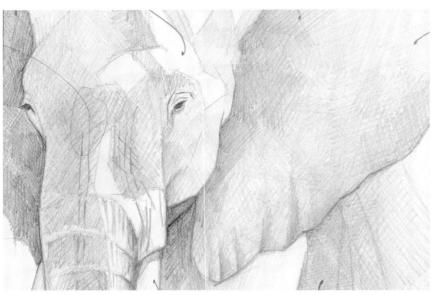

1 SKETCH AND TRANSFER
Focus on the general shapes of the elephant. They can be broken down into three distinct areas: the face, the left ear, and the body/right ear. Once you have those shapes drawn, you can find the contour of the core shadows as well as some of the larger wrinkles that help to define the pattern of wrinkles on the skin.

I made notes to work the wrinkles on the trunk and give them as much contrast and detail as possible and also push the darker values on the ears to make them recede into the drawing. This will help give the effect of the elephant walking right off of the page.

Once you have your composition worked out, create a contour sketch and transfer it to your final drawing surface.

STUDY ANATOMY TO IMPROVE YOUR DRAWINGS

One trait of skin is that it will show the underlying skeletal and muscular structures of the animal you are drawing. In order to become better at drawing wildlife, it is important to study the anatomy of your subjects. This might seem like a very daunting task, but it will strengthen your knowledge and you'll find yourself drawing things that cannot be seen in the reference photo but that you know are there.

Visit artistsnetwork.com/drawrealisticanimals to download a free bonus demonstration.

2 STRUCTURE THE WRINKLES AND ESTABLISH THE EYE

Wrinkles are a bit complex and have a definite pattern, so once you have your contour lines down, spend a little time finding more of the underling structure of the elephant's wrinkles with a 4H pencil. Don't spend too much time on details now because later you'll just end up covering most of the work you did.

Continue using the 4H pencil to establish the eye. Build the base layer of value and pull out just the bare idea of the structure.

3 LAY IN BASE VALUES ON THE LEFT EAR AND WRINKLES

Use a 4H pencil and crosshatching to establish a base value on the left ear, pushing back the shape so you can see the edge of the head better. Use the contour drawing on the trunk to lay down the base values on the shadow side of each wrinkle. The light is coming from the right, so the leading edge of each wrinkle is on the right side. This is where the light is strongest. The value will get darker as it moves to the left on each wrinkle. Keep the individual shape and darkness of each shadow slightly different, but the side that is in the light should not change.

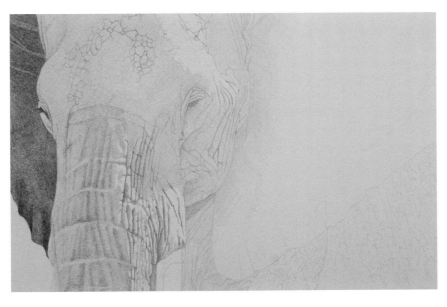

4 BUILD VALUE AND DEFINE THE WRINKLES AND VEINS

Add another value layer on the left ear with a 2H pencil and crosshatching. Use an HB pencil to build a third layer of value and to push some of the edges that define the subtle folds in the ear and the ridges of the veins.

You're moving from background to foreground here, so be careful to not overdraw or create too much contrast in any part of the background. Reserve that for the focal point and foreground objects.

5 BUILD UP THE BODY

Lay in the first value layer on the body with a 4H pencil and crosshatching. Think of the body and front leg as cross sections of a large cylinder. The light comes from the right, so the left part of the leg and the area where the body curves back behind the leg will darken as they recede. Build a second layer of value with a 2H pencil. Identify some of the major creases and folds in the skin using scribbling. Start the next value layer in the deep shadow area on the front leg/chest and in some of the folds of the skin with an HB pencil. Use crosshatching in the larger areas.

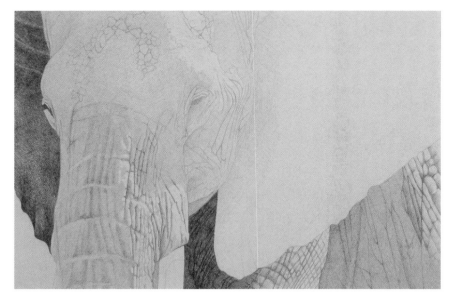

6 DEFINE THE FOLDS AND WRINKLES

Revisit each skin fold, pushing the values on the shadowed sides. Use a sharp HB pencil and scribbling to pull the values into the lighter side of each fold. Keep your hand pressure light. Add the next layer in the same manner with a 2B pencil, but don't pull the value as far into the light area. Continue with the 2B pencil to define some of the deep skin creases in the light area to the right of the leg. The folds of skin are deep but tightly compacted so the wrinkles move from dark to light quickly.

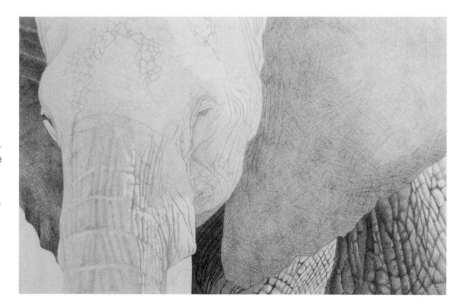

7 BUILD UP THE EAR AND PULL OUT THE VEINS

Build a fourth layer of value on the front leg/chest using a 2B pencil and both crosshatching and scribbling. Redefine some of the wrinkles but be careful not to make them too dark. Add another value layer in the deep shadow with a 4B pencil. Pull some of the value down into the folds of the skin.

With an HB pencil, add a third layer onto the large flat area of the ear. Establish the subtle folds and veins. Make the folds at the edge of the ear large with a gradual transition from one value to the next. Keep the folds near the head tight and vertical.

Flatten a kneaded eraser and use the narrow edge to lightly pull out the veins.

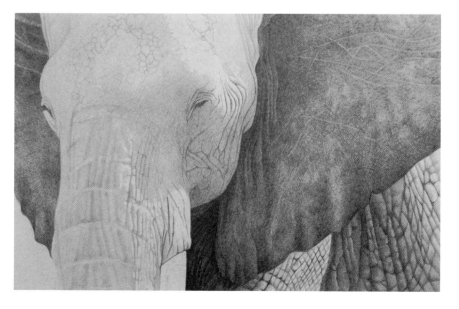

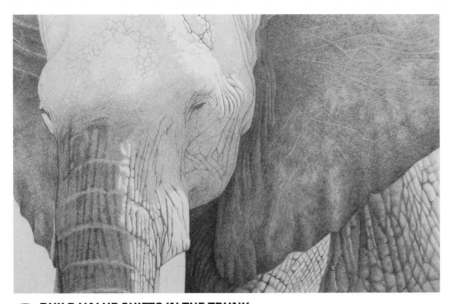

8 BUILD VALUE SHIFTS IN THE TRUNK

Go back to the trunk and continue building the second base layer with a 2H pencil. As you do this, you'll find that you need to keep redefining the wrinkles. Build the next value layer in the same manner with an HB pencil.

In the end, you want subtle value shifts that make the elephant come alive. If you are impatient and jump into the darks too fast, you will not be able to achieve those subtle realistic shifts in value that we find in nature. Resist the temptation to pick up your dark pencils in the beginning. The key to the layering technique (besides a constantly sharp pencil) is patience.

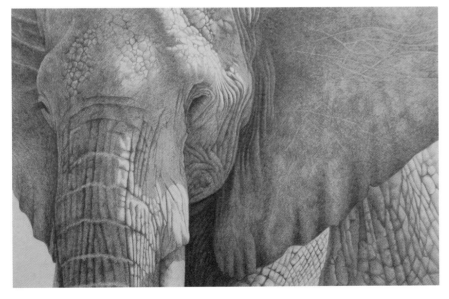

9 FINISH THE TRUNK AND DETAIL THE MUD

Bring the core shadows all the way up the elephant's face, following the same method you used on the trunk in Step 8, with a 2H pencil and then a layer of HB pencil. The main difference with the upper head is that you are dealing with the influences of the elephant's skull.

The skull makes the brow of the elephant protrude a bit over the eye, helping to catch the light. Because the trunk is all muscle and heavy, it pulls the skin almost flat towards the top of the head.

But this elephant has recently taken a mud bath, so there is the added texture of dry caked-on mud. Create this in the same manner as the deeply creased folds of the skin, but with the benefit of no distinct pattern. Remember to add cracks to the dried mud. Since the skin here is pretty flat, you have a little more freedom in this area. At this point, you should have three good layers on the trunk and head.

10 FINISH THE WRINKLES AND EYELASHES

Finish the wrinkles on the trunk and head with a sharp 2B pencil. Use scribbling and go into each fold on the shadowed side, pushing the darkness deeper. In high-contrast drawings, you want to look for areas where you can really push those values deeper. One such place in this drawing is where the elephant's ears meet his head. These are basically hinge points where a different plane starts and moves away from the head, creating deep creases that you can fill with value.

Darken up the areas around the eye and pull out the eyelashes. Start with your pencil at the eyelid, the origination point, and pull out in the direction of the eyelash, lightening up on your pencil pressure as you get to the end. Then take a craft knife, turn the blade upside down and scrape out the last few eyelashes that are being hit by the light.

Push the darks in certain areas as needed with a 6B pencil.

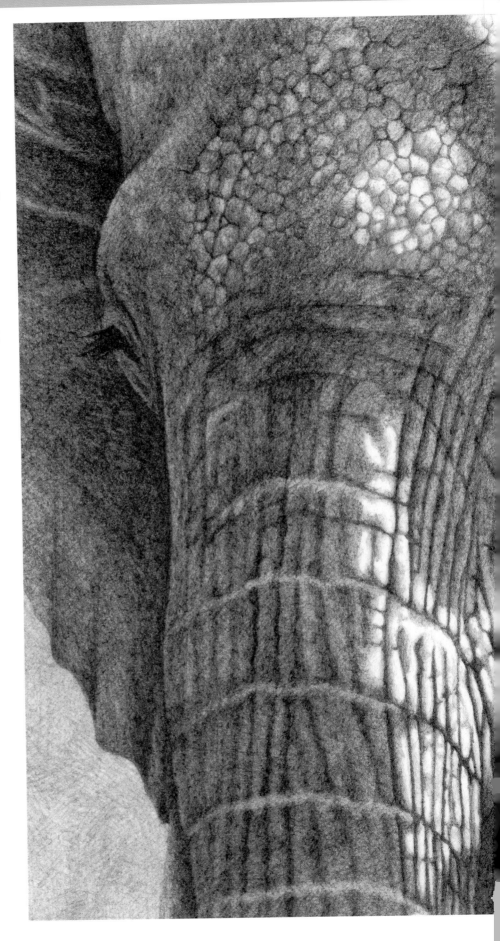

Hekima (African Elephant)
6" × 9" (15cm × 23cm)
Graphite on Arches #300 (640gsm)
cold-pressed watercolor paper

Visit artistsnetwork.com/drawrealisticanimals to download a free bonus demonstration.

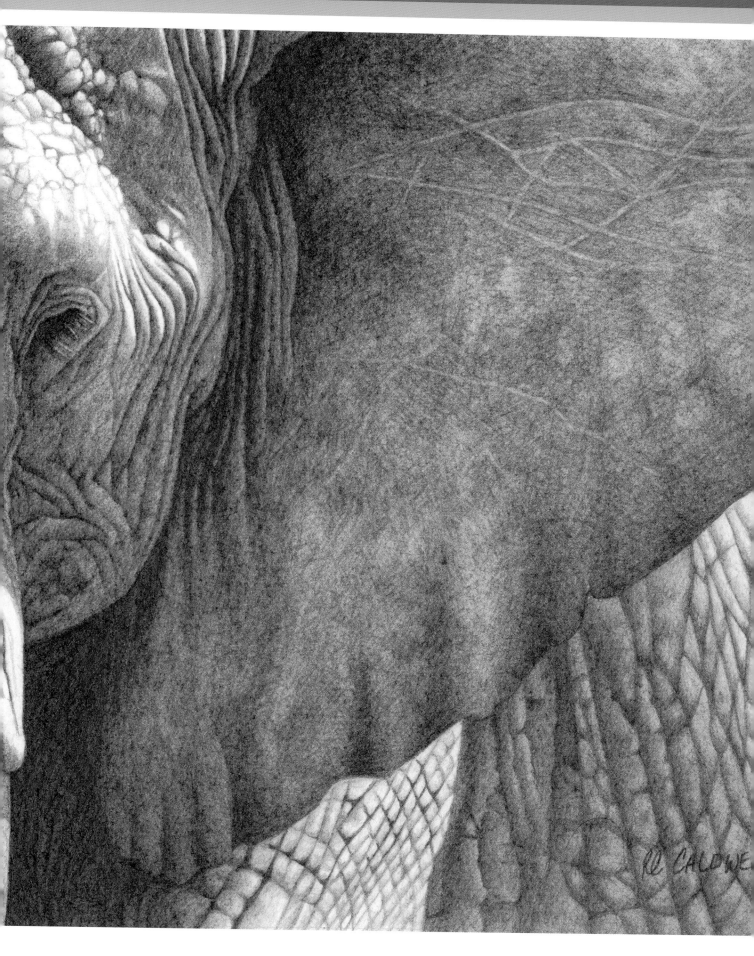

Northern White Rhinoceros

The horn of a rhino is just one of the many textures that you'll see in this demonstration. It will also give you more practice with drawing wrinkly skin. We will work through the entire process of drawing the rhino, with specific focus on the horn towards the end.

This composition has a nice balance of light and shadow on the rhino's body, as well as some darker areas in the background that help break up the shapes and keep the eye from going off the surface. The primary focus of this drawing is not the rhino but the superb starling on the ground. The strong vertical layout with the high contrast of values between the sunlight side and shadow side of the rhino, as well as placing the starling a third of the way up from the bottom and a third in from the side help direct the eye toward the starling.

Materials

- *Arches #300 (640gsm) cold-pressed watercolor paper*
- *4H, 2H, HB, 2B, 4B and 6B pencils*
- *kneaded eraser*

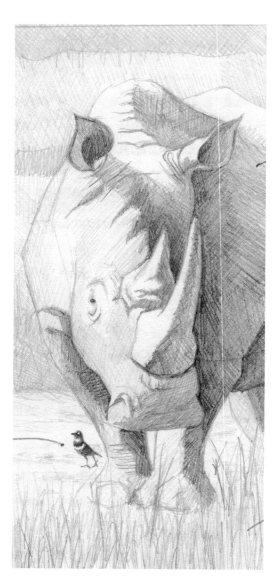

1 SKETCH AND TRANSFER

Find the major shapes of the rhino as well as the larger shapes in the background. Pay a little more attention when sketching the starling, only because it's the focus of the drawing. In my composition notes, I indicated that the grass is to fade in value and lose detail as it moves up the picture plane. This will help make it look like the grass area behind the rhino is receding into the distance. Be careful how much detail and contrast you put into the foreground grass. Too much and we'll focus in on that instead of the starling and rhino; too little and it will look like the grass belongs behind the rhino.

KNEADED ERASERS HELP CREATE WEAR-AND-TEAR EFFECTS

Horns, tusks and antlers are used mainly for defense and will show signs of wear and tear on their surfaces. First approach the basic shape, then look for any special characteristics and mimic the wear and tear on these parts. To do this, I employ my least-used tool, the kneaded eraser. It is a very useful tool for creating random wear on a hard surface.

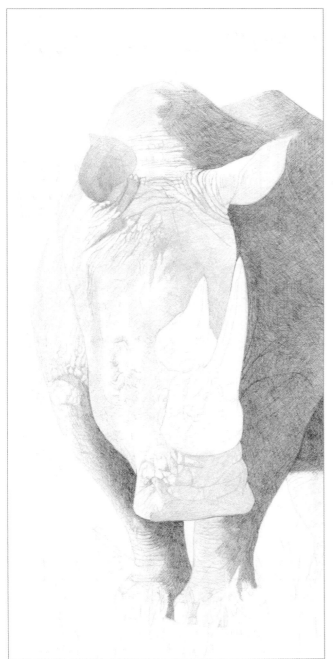

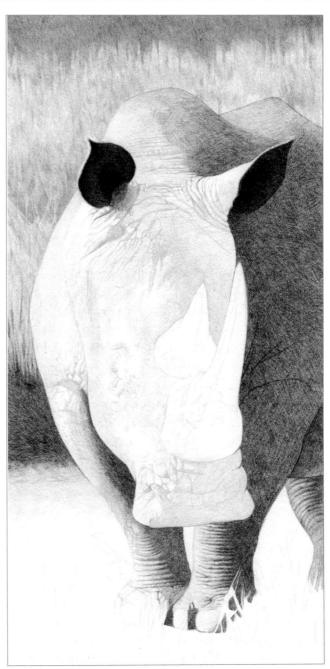

2 LAY IN THE BASE VALUES

Start in the core shadow area of the rhino. Lay in the first value layer with a 4H pencil. Then add a layer with 2H pencil, using crosshatching to build the base values. Establish the darker values in the sunlit portion of the rhino with a 4H pencil. Add a third layer of value to the shadow area with an HB pencil. Spend some time finding the wrinkle creases. Preserve them by redefining them with each new layer of graphite.

3 BUILD UP THE EARS AND LAY IN THE BACKGROUND

Build up the dark values in the ears with a 2B pencil and crosshatching. Use a 4B pencil and scribbling with hard pressure for the deepest darkest recesses of the ears. At this point, it's OK to crush the tooth of the paper because you're nearly finished building values in this area.

Use crosshatching with a 4H pencil to completely cover the background, establishing a darker value than the highlighted areas of the rhino. Add a second layer with a 2H pencil and pull out details of the grass. As with drawing fur, focus on the negative spaces by the lighter pieces of grass. Draw the opposite of what you think you should be drawing. Continue this technique with the third value layer, using an HB pencil to create even deeper negative spaces in the grass. The lighter grass areas will appear as you work in the shadows.

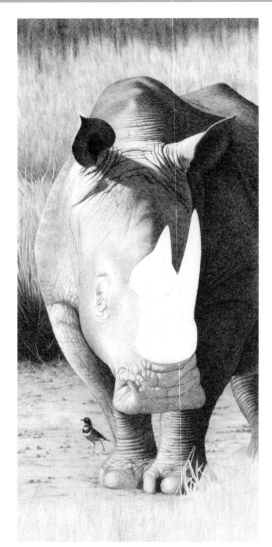

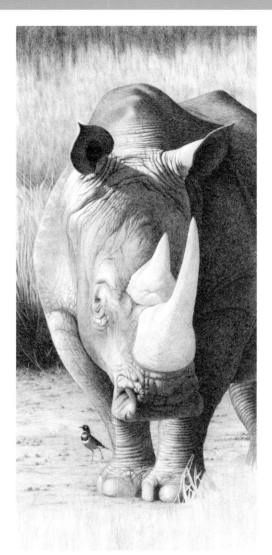

4 FINISH THE BACKGROUND, BEGIN THE FOREGROUND, AND BUILD UP THE BODY

Finish the background by layering 2B pencil in some of the darker areas of the grasses.

Begin the foreground with a base layer of 4H pencil. Use crosshatching but keep your lines going from left to right to give the perception of ground. Use a 2H pencil and scribbling to create a random piece of African detritus.

Build the base layers of the starling, going through the pencil grades before getting to the darks. It is essential to keep your pencil sharp at all times and use scribbling because the bird is so small.

Darken up the right shadowed side of the rhino with 2B and then 4B pencils. The 2B pencil gives a nice solid dark value and the 4B pencil lets you push the very deep shadow areas helping to define some of the larger wrinkles, the separation from the body and the head and the furthest shadow on the back leg.

In the highlighted areas of the rhino, lay in the base values with a 4H pencil. Work your way down into the wrinkle creases with a 2H pencil. Use an HB pencil to establish the shadow parts of each wrinkle as you did with the African elephant. The light comes from the left, so each wrinkle will be highlighted to the left where it catches the light. It will get darker as it rolls to the right into shadow. The amount of darkness and the rate that it becomes dark varies depending on the size and depth of each wrinkle as well as where it is on the rhino's body.

5 FINISH THE RHINO'S BODY

Finish up the left side of the rhino. Most of the darker area in the lighter side of the rhino's face is drawn in with a layer of 4H pencil and then a layer of 2H on top of that. Much of this is accomplished with crosshatching. As you start to work with the subtleties and the 2H layer, use scribbling more and more. Work the dark end of the core shadow over into the lighter area with an HB pencil to give it a more natural, realistic look. Also, focus in on the deeper folds, pulling out the value a bit into the lighter sides of each fold as well as pushing back the deeper part of the creases.

Spend some time around the eye making sure everything is nice and crisp. Do the same where the skin ends and the horn starts. There are a lot of tight creases and tears on the skin in this area.

Visit artistsnetwork.com/drawrealisticanimals to download a free bonus demonstration.

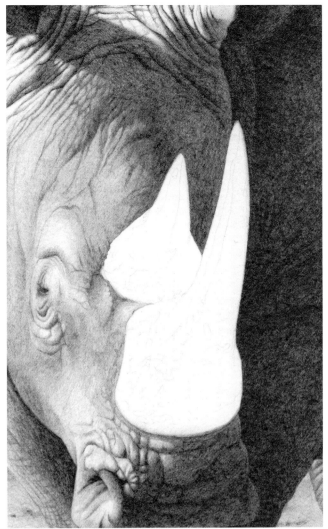

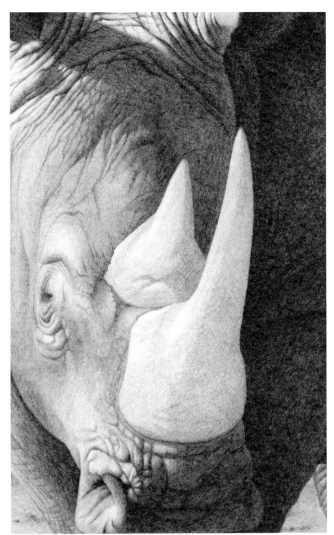

6 STUDY THE HORNS

The original transferred contour drawing is still preserved and ready for the first layer. Much of the information in the contour drawing will be covered over in the next few steps, but don't let this hold you back or let yourself get too tied down to those lines.

First, look at the simple shape of the horns—cones. A rhino's horn is about as close as you are going to get to an actual geometric cone, because a rhino's horn is pretty much smooth. You will have to deal with the wear and tear of the horn's surface, as well other surface characteristics, but as long as you establish the form of the cone first, you'll have a good base for those characteristics.

7 LAY IN THE INITIAL VALUE LAYERS

Build the first layer of value with a 4H pencil and crosshatching. Start in the core shadow area and move into the lightly shadowed area of the highlighted side of the horns. With a 2H pencil, start to lay in the second layer. Continue to use crosshatching, but start to identify some of those surface characteristics.

Watch your back-and-forth motion with the pencil lines. Keep them nice and tight, about ½" (1.3cm) in length. Because the surface of the horns is hard, you do not want your pencil lines to create any texture other than that of a hard smooth surface.

8 CONTINUE BUILDING VALUE

With a very sharp HB pencil, start in on the third layer of value. Continue crosshatching but get even tighter with the back-and-forth motion of the pencil. Begin scribbling to work a darker value subtly into the lines that look like growth rings. These lines are still relatively smooth, so watch how dark you make them. Finish off any other surface characteristics that need to be a bit darker.

9 DEFINE THE HORN EDGES

With a 2B pencil, move up the front of both horns, creating a nice dark edge. The edge that you want to create on the left is soft because the horn is round, so it transitions softly from one value to another. Bring the value over to the right of the horn but back off on the pressure some so that you retain a lighter edge.

A little bit of light makes its way around the horn. You don't want to lose that because it helps separate the horn from the darkness of the rhino's body. Darken the very top of each horn with a very sharp 4B pencil.

For continuity of values, work along the edge of each horn to pull some of the darker values into the edges where the horn meets the skin. Alternate between the HB and 2B pencils, just darkening up the little areas that need it.

Visit artistsnetwork.com/drawrealisticanimals to download a free bonus demonstration.

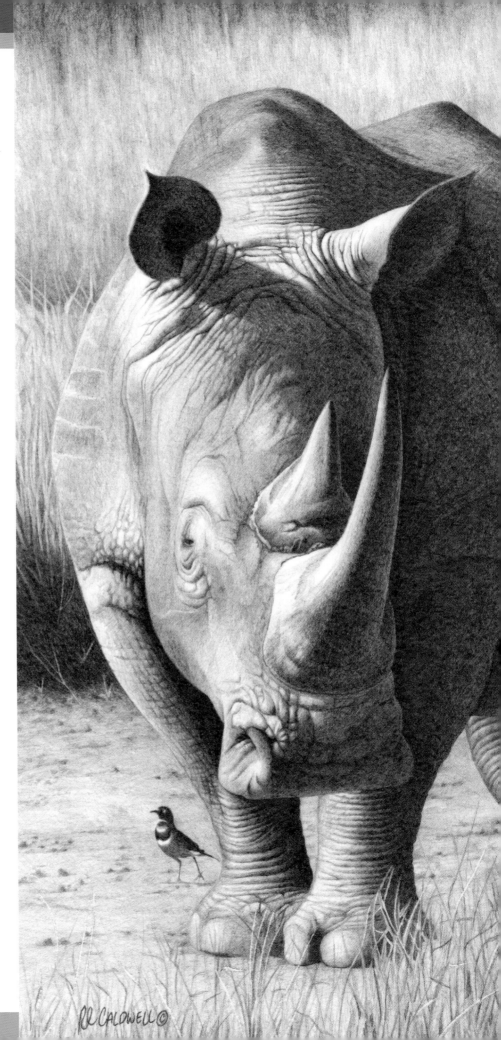

10 FINISH THE FOREGROUND

Darken the deep shadow on the left leg and the shadows in the ears with a sharp 6B pencil.

Some of the initial layer from the background will have worked its way down into the foreground grass—that is perfectly fine. Use a 4H pencil to start pulling out grass. Work with the grass that is farthest back and actually draw the blades of grass. Don't push too hard with your pencil.

Come back in with a 2H and then an HB pencil and darken some of the blades. Do the same thing with the area of grass in front of that—some of these will start at the bottom of the picture plane. Create one last row of grass again in the same manner, but at the bottom darken up the little negative shape areas that resemble the deeper recesses of the grass. Remember to be very organic with your pencil lines at this point and to not create a pattern in the grass by evenly spacing the blades.

With the grass in the foreground finished, the drawing is complete!

Superb (Northern White Rhinoceros)
13" × 6" (33cm × 15cm)
Graphite on Arches #300 (640gsm)
cold-pressed watercolor paper

R.L. CALDWELL ©

Sumatran Tiger

You don't have to go out on safari or travel around to exotic places to compose a simple portrait piece, yet it can have so much impact. The reference for this tiger drawing came from the National Zoo in Washington, D.C. I liked the position of the tiger's head, and the dark stripes contrasting with the bright white stripes made for a great challenge. I also loved the way the white whiskers swept back away from the face and pulled the eye back into the composition. I made the background black because I have not had the privilege of seeing a Sumatran tiger in its natural habitat yet. It also gave me the opportunity to play with lost edges, where there is no distinction between one form and the other—they just flow together.

This demonstration will focus on drawing the eye, but we will follow the progression of the entire drawing as in the previous lessons. This is also a good opportunity to revisit drawing fur and practice drawing the negative spaces between the positive shapes that make up the fur that we see.

Materials

- *Arches #300 (640gsm) cold pressed- watercolor paper*
- *4H, 2H, HB, 2B, 4B and 6B pencils*
- *kneaded eraser*
- *craft knife*

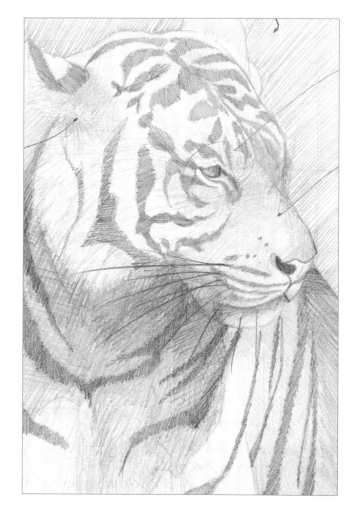

1 SKETCH AND TRANSFER

Work out all the information that you'll need as you move through the actual drawing. Capture all the general shapes of the tiger. Since the stripes are a major identifying characteristic, make sure to find those shapes in the sketch—don't wait for your final drawing surface.

In my sketch notes, I identified the eye as the focal point of this drawing. It falls within the Rule of Thirds in the composition. Instead of drawing certain details on this sketch, I just made note of them, such as the fur at the base of the ear that will be sticking straight out. This requires a different type of pencil line than what you would normally use for drawing fur.

Once you have your composition worked out, transfer the contour drawing to your final drawing surface.

Visit artistsnetwork.com/drawrealisticanimals to download a free bonus demonstration.

2 ESTABLISH THE BASE LAYER FOR THE STRIPES
Because the stripes are a defining characteristic of the tiger, build those up first with a layer of 4H pencil to create the base layer. These stripes will also end up being some of the darkest areas of the drawing.

3 ADD THE NEXT VALUE LAYER AND STRUCTURE THE EYE
Add a second layer to the stripes with a 2H pencil. Do not worry about any details or trying to make the fur look accurate at this point. Just get some good base values built up in the stripe areas so you can use those to pull out fur detail and structure later on. With the second layer of graphite on the stripes, go back in and build up that first layer of value in all the core shadow areas with a 4H pencil.

After establishing those important base layers of value, you can begin to build structure around the eye. When drawing eyes, it is important to remember that the basic shape of the eye is a sphere. The socket and eyelids will also take on the form of a sphere. At this stage, you want to make sure that the outer edge of the eye is arched and that you feel like you could trace the rest of the sphere back into its socket. The upper and lower eyelids should cut the arch of the eyeball at the top and the bottom, so these need to feel like they are sitting on top of the eye.

4 BUILD VALUE IN THE STRIPES AND AROUND THE EYE

Lay down the third layer on the stripes with an HB pencil. Use a 4H pencil to apply a base layer to the non-stripe areas of the tiger's body. At this point, you are bringing the drawing from a whisper up to a shout.

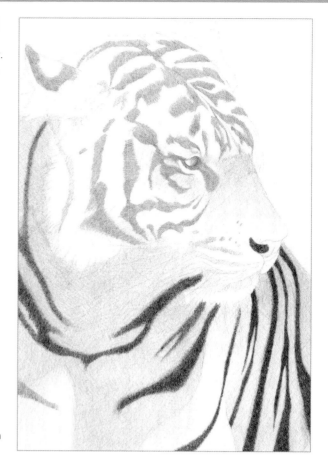

EYE

After establishing the first couple layers of value on the stripe shapes around the eye, you will be able to see the lines from crosshatching. Notice their length and how close together they are. Use a 2H pencil to push the darker eyelid rim back in value around the eye so that you start to see more of the actual eyeball. Pull some of the value on the eyeball up into the negative spaces between the markings of the lighter eyelashes on the upper eyelid.

5 BEGIN FUR DETAILS AND CONTINUE ADDING VALUE

Build up the stripes on the tiger's back with a fourth layer of graphite using a 2B pencil. Since you are working within the confines of the small areas of the stripes, keep your crosshatching very tight with the back-and-forth lines only being about ¼" (0.6cm).

Begin to bring out the fur characteristics by working on the negative spaces of the fur, not the actual white fur. Keep in mind that the hair lays on itself as it moves from the back to the front of the animal. So when you draw on the left side of each white stripe, you're drawing the negative shadow areas that are left behind from the overlapping white fur. As you draw on the right side of each white stripe, you're drawing the black hair that overlaps onto the white stripe.

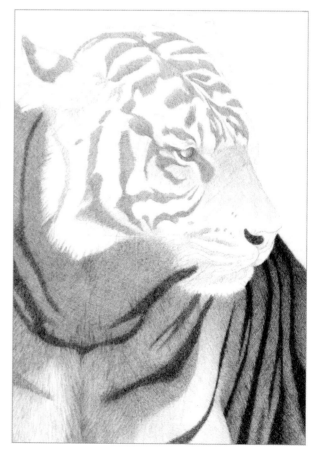

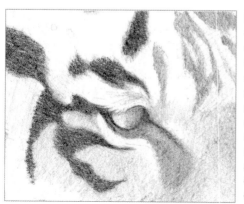

EYE

Continue building value in and around the eye so that you can better judge what needs to be done on the actual eye surface. Pull some of the HB value layer down from the stripe at the corner of the eye onto the lower eyelid.

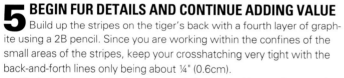

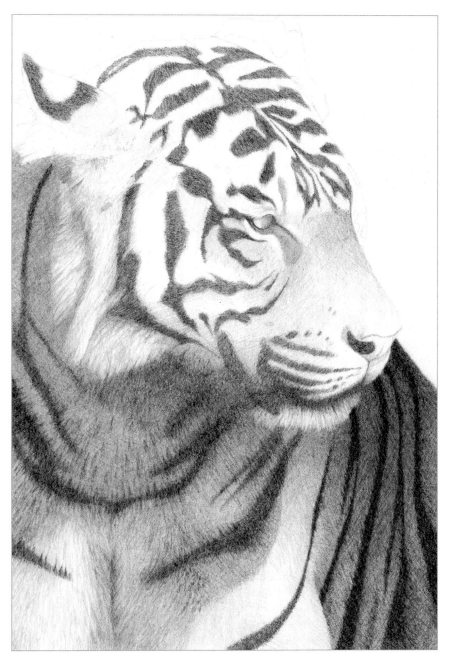

6 PULL OUT TEXTURE AND DRAW NEGATIVE SHADOWS

Use an HB pencil to begin pulling out the fur texture in the non-stripe areas of the tiger's body. Start to draw in the random negative shadow areas in the fur on the chest in the shape of little inverted *V*s. Make sure you are moving in the direction of the fur. The *V*s on the chest should be smaller because the hair is shorter. Make the *V*s longer at the back of the head under the ear. The hair there is longer, so it requires longer pencil lines to describe that area.

EYE

With an HB pencil, continue building the negative shapes around the eye to help define the white hair in that area and show the direction of the fur. Darken up the actual eyeball itself. You have already started the cast shadow on the eyeball from the upper eyelid as well as the shadows of the eyelashes. It is very important to always find the shadow on the eyeball; this is what makes it look real.

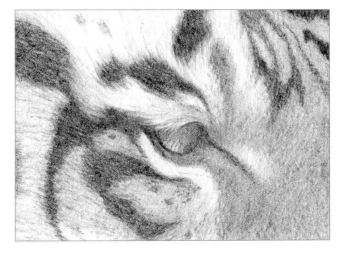

7 LAY IN THE BACKGROUND

Shift focus to the background, which will actually become part of the tiger's body with the lost edges; this will help to visually push the tiger's head out towards the viewer. Lay in the first three layers of value starting with a 4H pencil, moving up to a 2H, and finally an HB pencil. Use crosshatching for all three layers. Because the background is going to be so dark, keep your lines close together so you fill in all the spaces with graphite. You can start to see that a lost edge on the tiger's neck has already been established between the tiger and the background.

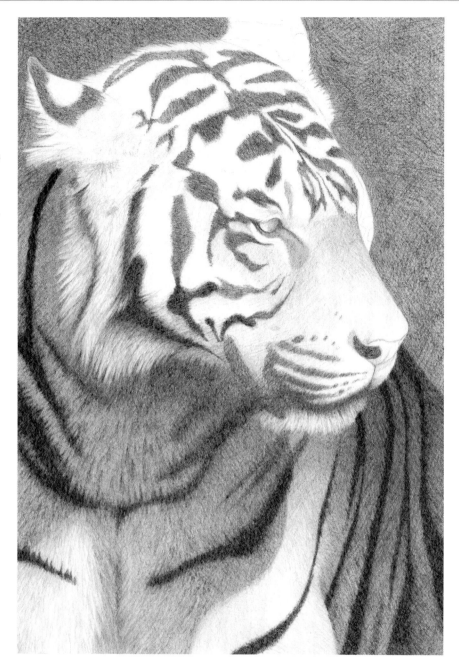

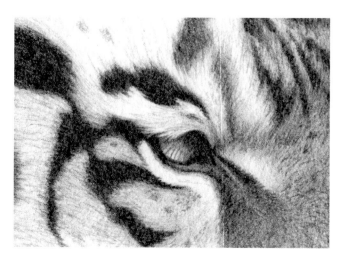

EYE

Push back the darks of the stripes around the eye. With a sharp 2B pencil, go into the eyeball area and add in another layer of value. Since this is such a small area, choke up on your pencil and use scribbling. This is the detail stage, so it's OK if you crush some of the tooth of the paper, because you spent the time to properly build the underlying values.

Visit artistsnetwork.com/drawrealisticanimals to download a free bonus demonstration.

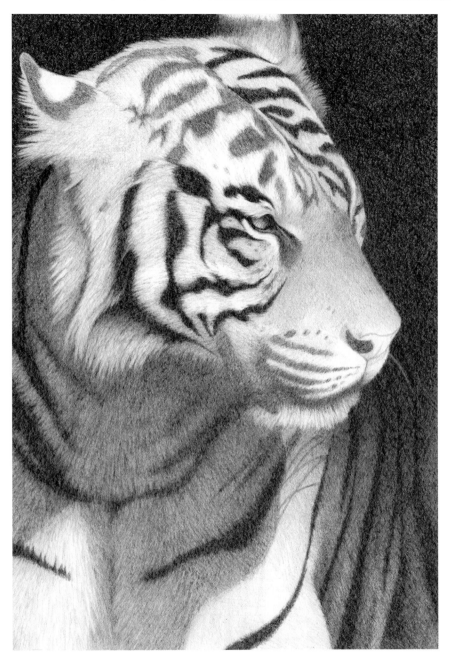

8 FINISH THE BACKGROUND

Add another background layer with a 2B pencil. Layer 4B pencil over that. As always, keep your pencils sharp. Just getting the background to this depth of darkness is already making an impact on the drawing. You can see now that you've completely lost the edge on the tiger's back. The tiger now flows right into the background.

EYE

Carefully define the edge of the iris with an HB pencil. Don't go too dark, just enough to be able to read it as the iris. Go over the upper eyelid shadows and crisp up the lines. Slightly define the pupil of the eye with a sharp 2B pencil. That part of the eye is in shadow, so be careful not to over define it. Remember, you can always darken something up more, but it creates problems to have to lighten an area back up. Darken up the lower eyelid edge some more with a 4B pencil. The eye is finished!

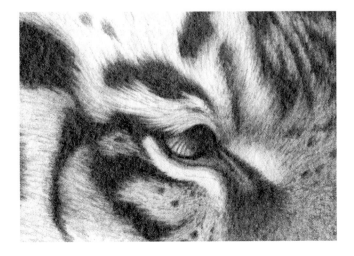

9 DARKEN THE SHADOW AREAS

With an HB pencil, go back over the core shadow cast on the front of the tiger's body, giving it a more solid tonal mass. Draw in some more random inverted *V*s. Switch back and forth between HB and 2B pencils as you continue working on the negative shadow areas of the fur. When working with the bottom and right edges of the white stripes, remember to pull the negative spaces up into the white areas. This will create the pieces of white hair and the individual black hairs overlapping into the white.

On the front right leg and base of the ear, there will be a different type of texture where the fur basically sticks right out. Use a 2H pencil and make your lines extremely short—almost dots that describe the inner recesses of the shadows between the hairs. Draw what you see and not what you think you know. As the spots get darker, so should your pencil. Use a 2B pencil for the deepest shadows just under the ear.

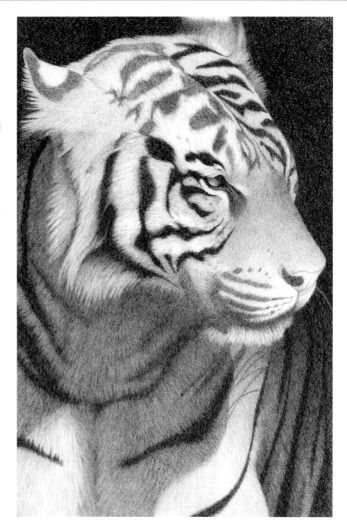

10 FINISH THE FUR TEXTURE AND ADD WHISKERS

Use HB and 2B pencils to continue to bring out the fur texture, remembering how the fur lays and in what direction it moves. Once again we have some extremely short hair on the tiger's snout. Keep these lines very short and thin. As you apply them, be careful that you don't create a pattern. It is natural human instinct to move your hand the same distance each time, so make a conscious decision to create randomness.

When scraping out the whiskers, have a new blade in your craft knife and hold it upside down on the paper surface. Turn the drawing so that the beginning of the whisker, the side of the tiger's snout, is facing you. You will have more control over your hand and the knife this way. Don't try to copy the whiskers on the reference exactly, but study them and get a sense of where they are going. Slowly with light hand pressure, scrape the craft knife in the direction of the whiskers. Repeat for the remaining whiskers, long and short.

Please note that sometimes with watercolor paper, a cotton fiber will come lose and create more white than you intended. When you are finished with all the whiskers, go back in with a sharp 2H pencil and clean up some of the edges.

Push the darks in certain areas as needed with a 6B pencil.

Whiskers (Sumatran Tiger)
9" × 6" (23cm × 15cm)
Graphite on Arches #300 (640gsm)
cold-pressed watercolor paper

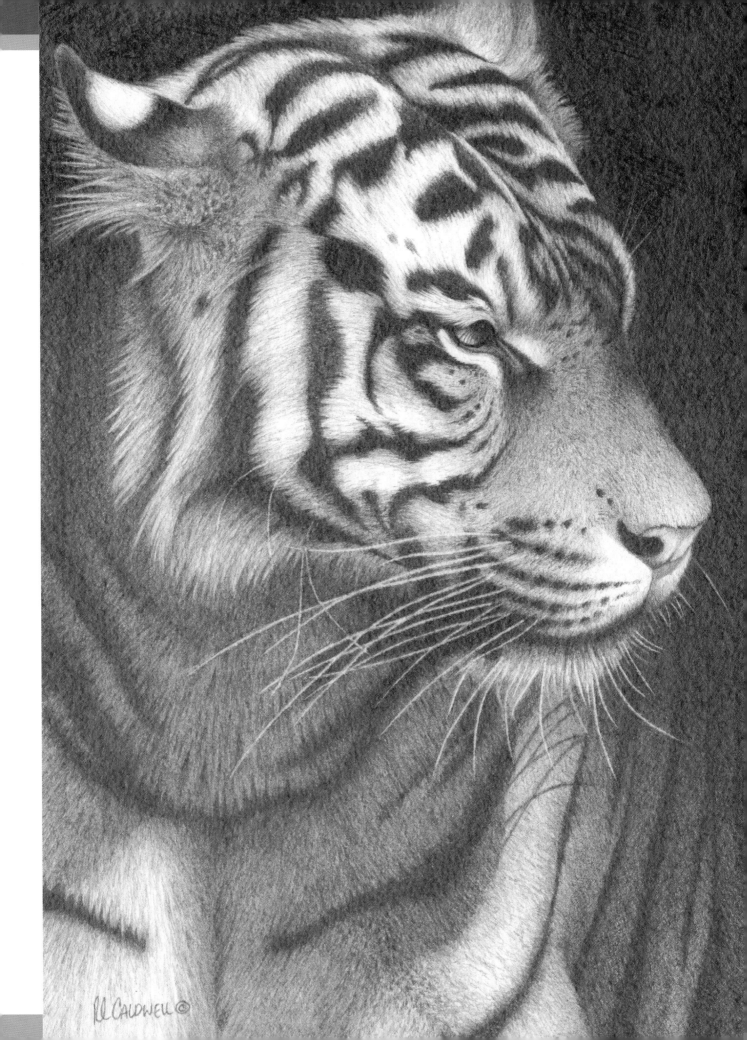

RL Caldwell ©

Lioness

Contrasting values and textures as well as creating an asymmetrical composition were my goals when putting this drawing together. This was one of those instances where you watch something unfold in front of you and know instantly that you want to recreate it. As I watched this lioness walk out into the grass in Tanzania, I knew that the contrast of the sleek and smooth textures of the lioness' fur against the coarse, almost jagged textures of the grass was something that I wanted to draw.

I was also amazed at how well the lioness blended into her environment—not only in color but in value, too. She almost became part of the grass and appeared to glide across it. I felt that compressing the top and bottom of the picture plane would help to emphasize this feel.

Materials

- *Arches #300 (640gsm) cold pressed-watercolor paper*
- *4H, 2H, HB, 2B and 4B pencils*
- *kneaded eraser*

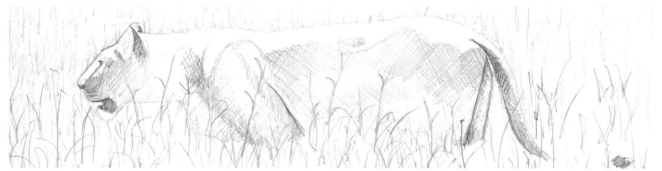

1 SKETCH AND TRANSFER

Compose the drawing, emphasizing the long slender body of the lioness moving through the tall grass by compressing the top and bottom edges of the picture plane to make the composition long. Try to capture the separation of light and core shadows on the lioness' body as well as some of the grass detail. When you transfer this sketch, leave the contour of the grass the white of the paper, since the dark values of the lioness' body contrast with the light of the grass. Include a very slight value change from the highlighted portion of her back to the grass. This will help show how the lioness blends in with her surroundings due to her coloring.

Visit artistsnetwork.com/drawrealisticanimals to download a free bonus demonstration.

2 ESTABLISH THE BASE VALUES

Build the first layer of value with a 4H pencil. Start with the focal point of the drawing—the face of the lioness. Build just enough structure to make the features identifiable. Continue with the 4H pencil along the lioness' back to establish a base value in the core shadow area. As you do this, draw in and around the grass, leaving the white of the paper.

The lioness may be the point of interest in this drawing, but the contrast between her shadow side and the light grass is what makes it interesting to look at. It is a contrast not only in value but in texture as well.

3 FINISH THE CORE SHADOWS AND BEGIN THE GRASS

Finish laying in the core shadow on the lioness with a 4H pencil. Begin building a second layer in the darker areas with a 2H pencil. Areas such as the neck, shoulder blade and long crease on the front leg will all become important as you move forward with the drawing. They are the start of the underlying muscles and bones of the lioness' body.

Create a definite line of separation between the lioness and the foreground grass. Do this by picking out the tall blades of grass first

and then the medium length ones, drawing around them so that you basically reveal the grass instead of actually drawing it. Once you get down to the smaller blades, start drawing in the negative shapes between the grass blades that show the lioness' body. At this point, as long as you get the right feel of the grass, its direction and size, you really can't make a mistake. Apart from the movement created by the lioness, the grass is static.

4 ADD ANOTHER VALUE LAYER AND BEGIN THE FUR

With an HB pencil, start to establish the third layer of value. As you do this, pull out the beginnings of the fur detail. Put in just enough detail to give the idea of the direction of the fur—at this point, you don't have enough of a foundation to hold the detail.

Further establish that line between the lioness and the light foreground grass. In essence, the play in value between the very light grass and the shadow side of the lioness is what this drawing is all about.

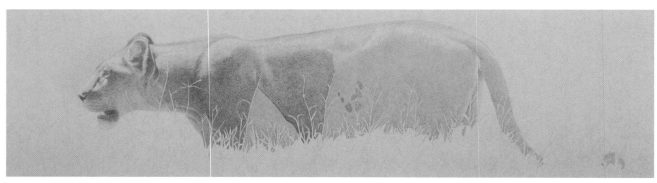

5 CONTINUE BUILDING VALUE

Continue building value with an HB pencil, moving from the head to the rear of the lioness. Break the drawing up into manageable pieces. It is much easier to work on one section at a time, and to only have to think about that section rather than the whole drawing.

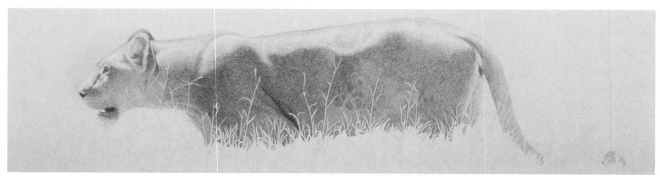

6 ADD MORE VALUE, PUSH THE DARKS AND CONTINUE THE FUR

Start to build the fourth value layer with a 2B pencil. Push the darks around the eye, nose and mouth. The high contrast of the piece should really start to show. As you build this next layer, continue pulling out some of the fur. Just like the cat you drew earlier, this big cat also has short fur. Keep your pencil lines short to create this short-fur texture.

Take a moment to study the lioness' fur. Pay attention to the direction it is moving and the areas where it seems to change. One of these areas is on the lioness' shoulder—the fur stops moving from the head to the rear and changes direction, moving from the shoulder to the foot. This is a distinguishing characteristic of the lioness. However, you don't want to draw it exactly like it is in the reference but rather use the reference as a guide.

Visit artistsnetwork.com/drawrealisticanimals to download a free bonus demonstration.

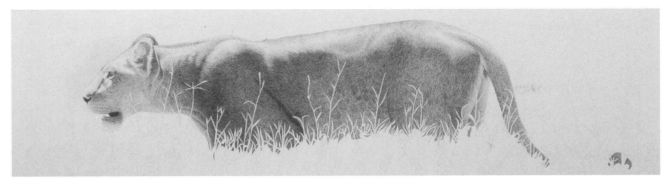

7 ESTABLISH VALUE SHIFTS AND THE FUR TEXTURE

Begin to focus on the subtlety of the lioness' coat. Establish the slight value shifts of the muscles that are under the skin. Switch back and forth between an HB and a 2B pencil, push the darker areas of value and bring out the short-fur texture. Carry that fur texture down into those little negative spaces in between the grass blades, and start to bring out the spots on the mid section of the body. The fur texture moves through these as well.

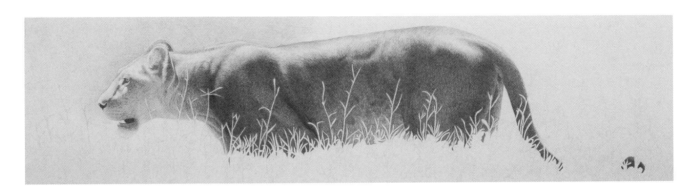

8 FINALIZE THE FUR TEXTURE AND MUSCLES AND LAY IN THE BACKGROUND

With a sharp 2B pencil, build more of the darks as well as the final short-fur texture in the darker areas. Continue establishing the muscles under the skin, as well as some of the ribs. These characteristics are what make the difference between using reference from a zoo and that of an animal that is free in its natural habitat.

Begin building the base value on the background with a 4H pencil. Push the overall value in the background back a bit so that the highlights on the lioness' back are the brightest part of the drawing—brighter than any highlighted blades of grass.

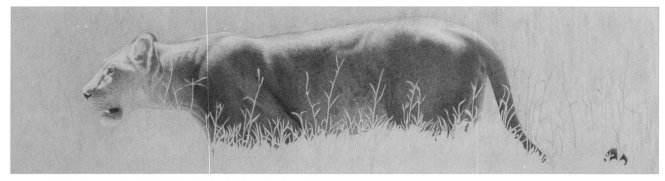

9 CONTINUE BUILDING THE BACKGROUND GRASS

Once the background base value is laid in, build the next layer of value with a 2H pencil. Since the grass is pretty light overall, you can start dealing with texture and pattern in this layer of graphite. The grass grows vertically, so make your pencil lines and the underlying grass texture vertical. The pattern in the far background is a recurring clumping of the grass, which creates shadow areas. However, you want this pattern to be more organic than distinctive. You can pull some of this clumping pattern down into the foreground area, making the grass a little longer in length and thinner in its shapes.

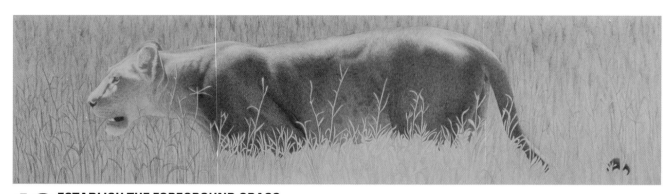

10 ESTABLISH THE FOREGROUND GRASS

Now that the far background feels more like a grassy plain, you can start to draw in the foreground grass. Switch back and forth between a 2H and an HB pencil at this stage, because some of the grass needs to be faint and almost disappear into the distance, whereas the closer grass should have more structure. Stop and take a few moments to really study the grass and get a sense of its pattern, shape and movement across the picture plane. We don't want to try and draw every blade just as it is in the reference but capture more of the sense of the grass in the reference.

Visit artistsnetwork.com/drawrealisticanimals to download a free bonus demonstration.

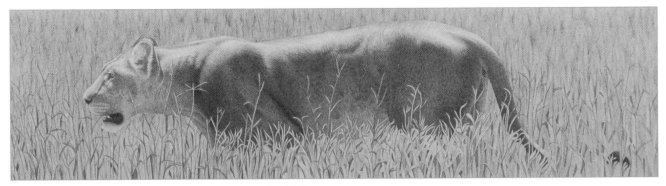

11 ADD DETAILS TO THE FOREGROUND GRASS

Thinking about the grass as you did in Step 10, move out to the grass that is in front of the lioness' body and back behind and around the tail. Give some more structure to the taller grass blades and the few medium ones, establishing a lighted side and a shadow side on the blades. Doing this to these and these only will be enough to give the rest of the grass the feeling of natural grass. You don't want to give all the grass the same level of detail, because that would be too much for the eye to look at.

The shorter grass and denser areas can all be established not by drawing more grass but by drawing the spaces in between the grasses and then drawing more shapes in between those areas. This can become a bit tedious because these are such small areas, and you can sometimes feel lost within your own drawing, but the time that it takes to do this is well worth it. Since the grass is lighter than most of the other elements in the drawing, it is much easier to draw around the grass then to actually draw the grass.

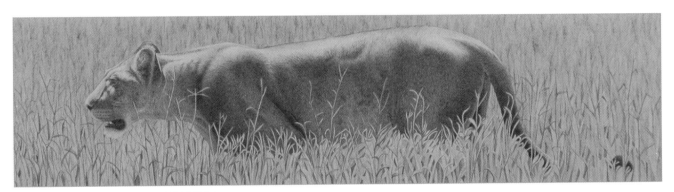

12 FINISH THE LIONESS' HEAD

Finish the lioness' head, switching back and forth between HB and 2B pencils as needed. Push the darks within the mouth even darker to reveal the teeth as well as some of the markings on the face, like the whisker spots and the spots on the cheeks. The entire eye is in shadow, so besides establishing the pupil and dark lower eyelid there isn't much to worry about aside from the direction of the fur as it moves out and away from the cat's eye. A final little push of the darks in the shadows of the ears to reveal the lighted longer hairs will finish off the lioness' head.

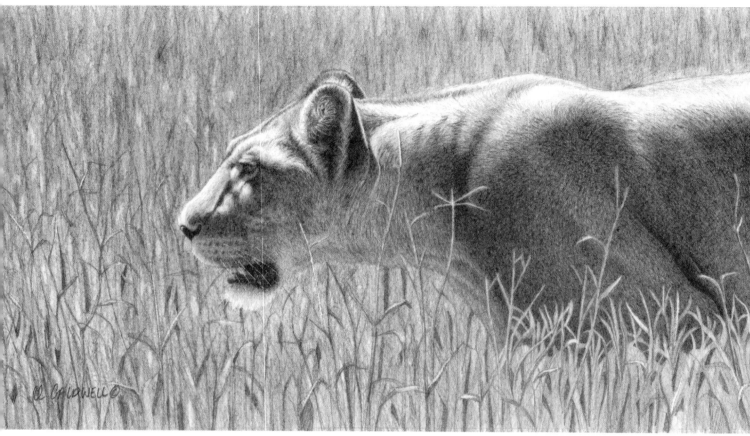

13 DARKEN THE BACKGROUND AND SHADOW VALUES TO FINISH

Build up another layer of value over pretty much the entire background. If the lighted areas of the lioness' head and back are not showing up enough, take a 2H pencil and darken up the background to make the lighted areas of the lioness really stand out.

Go back into the lioness and push some of the darks a bit more, increasing the contrast throughout the drawing. Work back and forth with 2B and 4B pencils to build value on the rear, tail, behind the front leg, and just in front of the front leg.

The finished drawing has a great contrast of values and textures. The very nice asymmetrical composition shows off this magnificent animal. Without a doubt, this drawing captures the look and feeling of the lioness walking through the savannah grass on that sunlit day.

Margin (Lioness)
Graphite on Arches #300 (640gsm) cold-pressed
watercolor paper, 5" × 19" (13cm × 48cm)

Private Collection
Selected for Art of the Animal Kingdom XVIII
Bennington Center for the Arts
Bennington, Vermont

Black-Capped Chickadee

You don't need to go too far from your house or studio to find something fun and interesting to draw. Unlike most of my drawings, this was a controlled setup. I knew that I wanted to draw a bird perched on a branch with holiday lights wrapped around it for my 2012 holiday card. I wrapped the lights around a small tree limb, attached it to a bird feeder in my backyard, and waited for the magic to happen.

This drawing is a great example of thinking back to the basic shapes. The entire thee limb is a cylinder. The bird is made from two spheres, one for the body and one for the head. And the light bulbs are cylinders with cones on the ends. Once you draw in the characteristics of each of these shapes, the details can confidently sit on top of them.

Materials

- *Arches #300 (640gsm) cold pressed- watercolor paper*
- *4H, 2H, HB, 2B, 4B and 6B pencils*
- *kneaded eraser*

1 SKETCH AND TRANSFER

The black-capped chickadee will be the point of interest in this drawing, which is balanced by the outlet plug and the length of the branch in the picture plane, making this an asymmetrically composed drawing. The background will be kept clean and simple to help balance the harsh lines of the man made wire of holiday lights.

As you move through this drawing, do your best to keep within the transferred contour drawing in order to retain the crisp white background.

2 ADD CONTOUR LINES AND LAY IN THE BASE LAYER

Once you have transferred your contour drawing, use a 4H pencil to build the first layer of value in the core shadow areas of the bird, as well as the defining characteristic of the bird markings, the black cap. This drawing has a relatively small subject matter, so keep your pencil sharp and use crosshatching. The back-and-forth motion of your pencil lines should be no longer then ¼" (0.6cm) giving you the most control you can get as you build that initial layer.

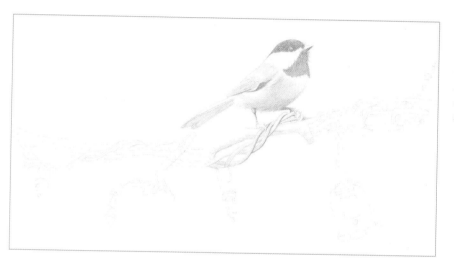

3 ADD THE NEXT LAYERS

Add the second value layer with a 2H pencil. Continue to use crosshatching in a very short back-and-forth motion, creating a nice even tonal mass. Build a third layer of value with an HB pencil on the black cap and eye of the bird.

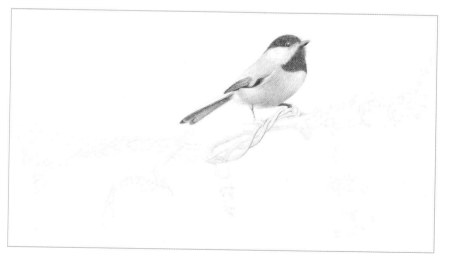

4 STRUCTURE THE TAIL AND WING AND ADD VALUE

Continue using the HB pencil to push the darks under the tail feathers and in the primary feathers of the bird's wing. Build value and structure in those two areas at the same time. Switch to a 2H pencil and work in another layer of graphite, creating a more smooth tonal mass over the bird's body. Start to pull out a little detail in the feathers on the bird's head. Since the right foot is in shadow, establish an overall dark value on that leg with an HB pencil.

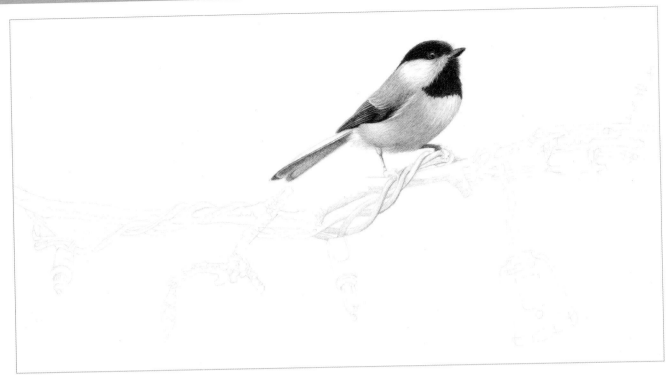

5 ESTABLISH THE DARK AREAS

With a very sharp 2B pencil, go back into the bird's head and establish the dark areas of the black cap markings. Use an HB pencil to pull out a few of the random little feather ends under the bird's bill, as well as the dark little negative spaces in between the white feathers on the bird's cheek. Establish the last intense dark value on the black-cap markings with a sharp 4B pencil.

Switch back and forth between HB and 2B pencils to push back the darks in the wing some more. Retain the wing structure as you do this. Since this is such a small area, you might find yourself choking up on the pencil so that you can control your pencil lines. That's OK because you are almost at the desired darkness.

Shift back to the bird's body. Its basic shape is that of a sphere, so work on darkening up the underside of the bird so it has more visual weight, giving it a round plump feeling. Keep your pencil lines going in the direction of the bird's body to create the barely visible texture of the body feathers.

6 FINISH THE BIRD AND LAY IN BASE VALUES FOR THE BRANCH AND WIRE

Using a very sharp 2B pencil, make one last push on the bird's chest to make the bird feel round. Now that the bird is finished, you can start to work on its perch.

With a 4H pencil, make your way down the branch and electrical wire. Block in the first layer of value in the core shadow area. Use crosshatching as much as possible, due to the very limited space of the shapes you are working with.

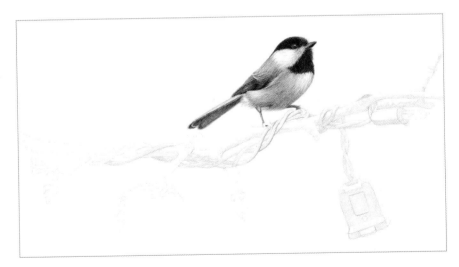

Visit artistsnetwork.com/drawrealisticanimals to download a free bonus demonstration.

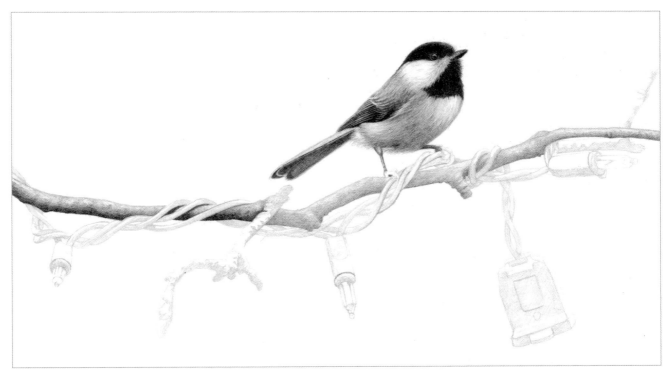

7 BUILD UP THE BRANCH

Continue to establish the core shadow on all of the branch, electrical wire and light bulbs, all with a 4H pencil. Concentrate more on the branch since the wire wraps around it. (This is the same concept as working from the back to the front of a drawing.)

With a 2H pencil, go back along the core shadow of the branch building a second layer. Then switch back to a 4H pencil to build a layer on the lighter side of the branch. Use a sharp HB pencil to push the darks along the shadowed side of the tree limb, easing back the hand pressure of the pencil as you move towards the lighter side. There is a slight texture in the branch that you'll want to start to bring out as well, but just subtly.

8 PUSH DARK AREAS ON THE BRANCH

The main branch should be pretty well established with value and form by now. The entire branch has a base value of 4H, creating a value difference from the background. The core shadow is made of two additional layers with 2H and HB pencils. Before you move onto the wire, go in and really push some of the dark areas on the tree limb with a sharp 2B pencil. Since the these deep dark areas are so small, you will need to constantly go back and sharpen your pencil to keep a good deal of accuracy and not to go onto the white background.

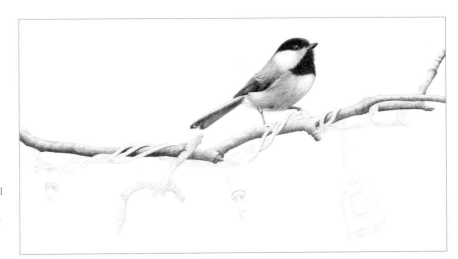

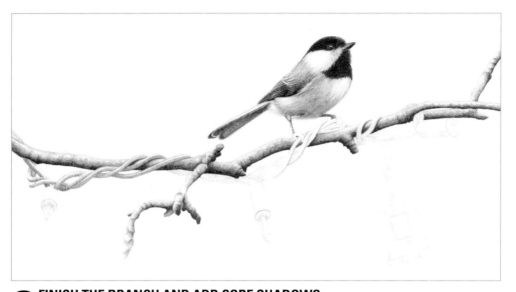

9 FINISH THE BRANCH AND ADD CORE SHADOWS

Finish up the little branch that sticks out towards the viewer in the same manner that you have done with the rest of the branch. Darken those last darks on the branch. Make sure that you don't go darker then the black-cap markings of the bird, but just dark enough to give the contrast that last little push it needs.

The electrical wire is accomplished the same way as the tree limb. Move along it with a 4H pencil, then with 2H and HB pencils. The difference here is that you need to make the soft edge of the transition line between the highlighted portion of the wire and core shadow extremely smooth, devoid of any texture at all. The area you're working in will be getting even smaller, so keep the point of your pencil sharp. Use scribbling and really control your hand pressure, especially as you get close to the soft transition line.

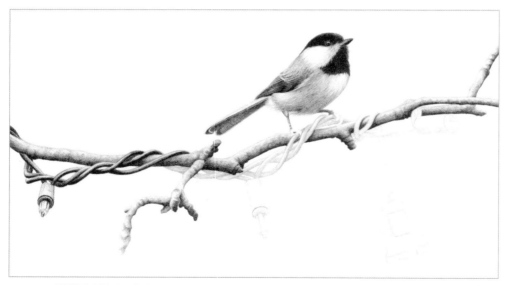

10 BUILD VALUES ON THE WIRES AND LIGHTS

The inherent value of the electrical wire is a medium dark, so make sure that most of the wire has a medium value on it. Notice how the highlights are brighter when the wire bends over another wire—the wire actually protrudes towards the viewer, capturing more of the light. It's these little subtle details to the structure of things that help to make your drawing look real and three-dimensional.

The glass on the light bulbs will have the harshest value shifts, almost all hard edges. The light bulb is made of glass and glass reflects what is around it. So what you are actually drawing are the reflections of the dark electrical wire and branch that is on the surface of the light bulb. With this in mind, draw what you are seeing and not what you know the object to be.

Visit artistsnetwork.com/drawrealisticanimals to download a free bonus demonstration.

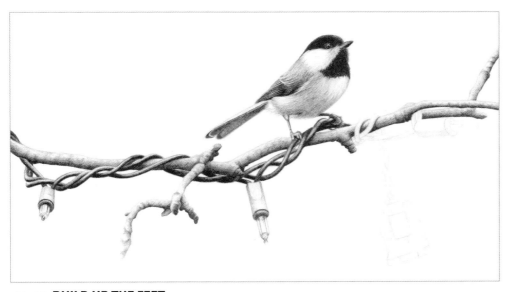

11 BUILD UP THE FEET

Notice how the wire under the tree is darker and just barely catches any light. This will happen under the bird too. As you work on the point where the bird's feet connect with the wire, slow down and look more closely at the reference photo. Really look at how the shapes around the feet area work together. Just like with the wire, if you pay attention to the hard edge and the soft edges of the claws, that will tell all you need to know about the structure of this area. Keep your pencils consistently sharp, working back and forth between 2H, HB and 2B pencils while working on the claws.

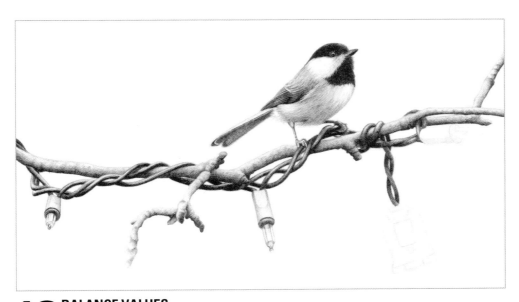

12 BALANCE VALUES

The outlet plug end should be relatively dark, just like the electrical wire. Looking at the drawing as it stands now, you may want to back off on that value so that you don't tip the balance of the piece. You want the outlet plug to help visually balance the chickadee, but not to pull it down.

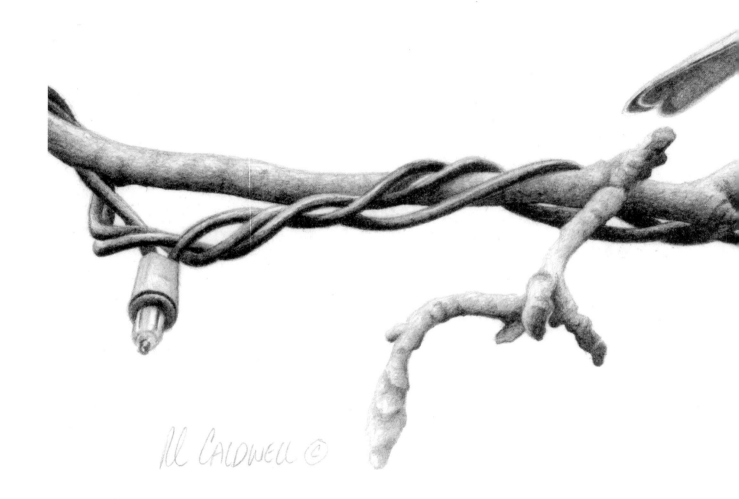

13 FINISH THE WIRE AND LIGHTS

Finish the electrical wire as well as the other two light bulbs and plug end. Continue to work as needed with your 2H, HB and 2B pencils to establish all these different values. Even in these small areas, you'll want to continue to build values and not jump to the dark pencils. Just because it is a small electrical wire, branch or birds beak, you still need to have a good solid base value to receive the next layer.

Push the darks in certain areas as needed with a 6B pencil.

Visit artistsnetwork.com/drawrealisticanimals to download a free bonus demonstration.

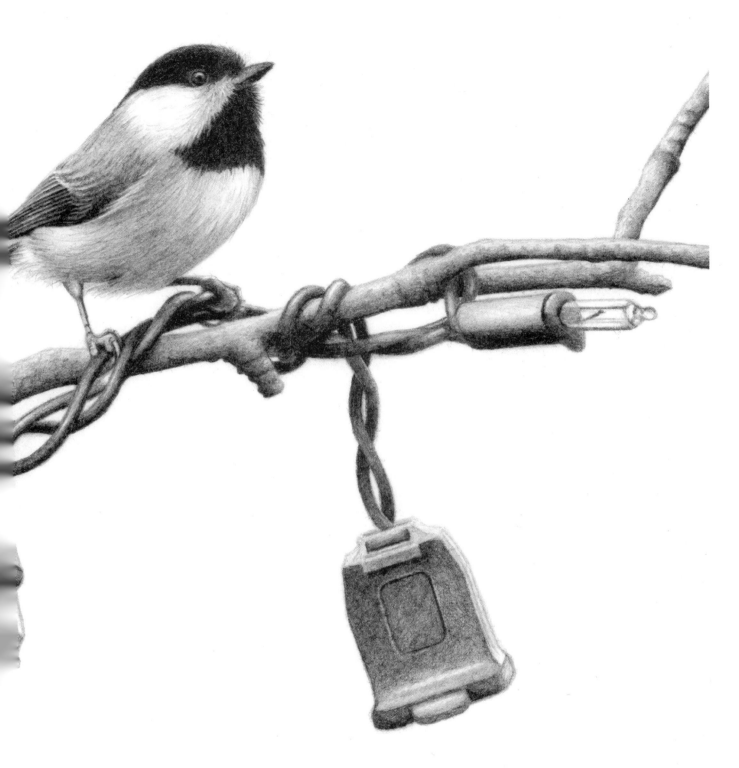

Chickadee in a Bradford Pear Tree
Graphite on Arches #300 (640gsm) cold-pressed
watercolor paper, 5" × 19" (13cm × 48cm)
Private Collection

Elephant Herd

Thirty Three (African Elephants) was inspired from my 2012 Africa trip and was an actual scene that I witnessed. This composition is thoughtfully composed from seven different reference photos taken that morning in the bush. I wanted to create the feeling of depth, so it was important to have some overlapping of different elements in the picture plane. I also wanted to convey a sense of movement from the left of the picture plane to the right. I think that the elephants' gesture with the light coming from the left, as well as the two helmeted guinea fowl caught in mid stride all convey that feeling.

As with some of my other African pieces, I really wanted to convey the high contrast of the Tanzanian sunlight. It was important to establish a value over the entire background, forcing the highlights to be brighter and creating the contrast that I desired. I also used the large static Baobab tree as a balance to the elephants' perceived movement across the picture plane. The tree balances with the foreground elephant as well.

Materials

- *Arches #300 (640gsm) cold pressed-watercolor paper*
- *4H, 2H, HB, 2B, 4B and 6B pencils*
- *kneaded eraser*

1 SKETCH AND TRANSFER

Many hours were spent on the composition part of this drawing, as well as several hours just on the sketch and contour drawings. It is the largest and most detailed drawing I have done to date.

Every elephant has been drawn out, establishing the lighter side and core shadows on each elephant, as well as the helmeted guinea fowl. Special attention was paid to the Baobab tree, making sure to find all the folds and nuances.

In my notes, I indicated that the very front elephant should have the greatest amount of detail and contrast and that each elephant would have less and less detail as it moved back into the distance.

I wanted the sky to feel as if it were moving away from the viewer, so I noted that there should be a one-degree shift in value form the top of the picture plane to the horizon line. This helps to give the drawing atmospheric perspective.

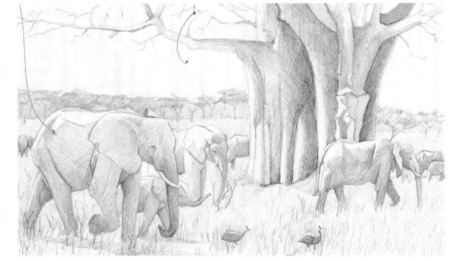

2 ESTABLISH THE BASE VALUES

Start with the focal point, the two front elephants, mother and calf. With a 4H pencil, build the first layer of value in the core shadow areas, separating the shadow form the light. With a sharp 2H pencil, push the dark values on the chest of the mother elephant a bit and redefine some of the wrinkle patterns. Create these values with crosshatching, but keep the pencil lines about ½"–⅓" (0.8cm-1.3cm) in length. This will help you keep control of the pencil.

3 CONTINUE BUILDING VALUE IN THE FRONT ELEPHANTS

Continue using the 2H pencil. Give the front elephants just enough value to give them some visual definition, but not much more than that. Start to move back into the distance. Visit each elephant, sticking with the base layer established with the 4H pencil and then adding another layer with a 2H pencil. Give just enough value to each elephant so that they look like they could be elephants. Do not get into any details at this point in time.

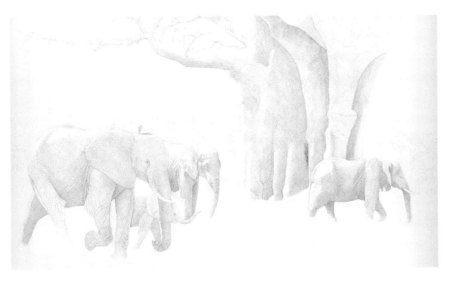

4 LAY IN THE TREE

The Baobab tree is the secondary focal point in this drawing. Separate the light from the shadow by building that first layer of value in the core shadow area with a 4H pencil using crosshatching. So you don't lose the "ribs" of the tree, go back in with a 2H pencil and define some of the darker folds to help maintain the structure of the tree.

While you are working on the tree, move up into the branches to get them established as well. Draw just the main branches at this point.

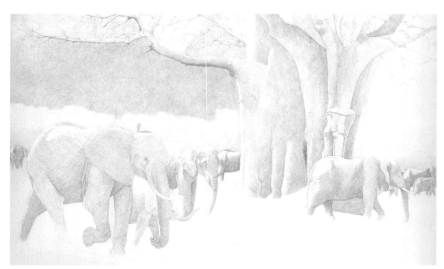

5 FINISH BLOCKING IN THE ELEPHANTS AND START THE SKY

Finish blocking in the other elephants in the distance. Stick with 4H and 2H pencils to block in the first two layers of values on each elephant, giving them each just enough definition to be perceived as elephants.

Begin building the first layer of the sky with a 4H pencil and crosshatching. You are probably thinking, *Oh my, the sky is dark!* Not to worry—it is just right. Skies are actually darker than we think. In our drawings we need to make sure that we push them

back some so that the highlights read right in the finished drawing. This goes back to working within the limitations of your materials.

As you build this base layer, keep your hand pressure light, allowing the weight of the pencil and the tooth of the paper to work together. Avoid as much crosshatching texture as possible and keep the back-and-forth lines about ½"- ¾" (1.3cm-1.8cm) in length. The longer the line, the more crosshatching texture.

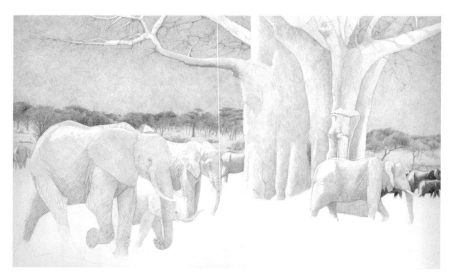

6 FINISH THE SKY AND DARKEN THE TREE

Continue across the entire background of the sky with a 4H pencil. Then come in with a second light layer of 2H pencil, working from the top of the picture plane down to the tree line. This shift in value is extremely light and is just enough to give a slight feel of a curve in the sky.

Darken up some of the branches in the tree's upper canopy with an HB pencil. Move forward into the tree line, establishing the base layer with a 4H pencil. Pull that value down into ground cover in the far distance. Build the second layer of value with a 2H pencil, getting it just a bit darker then the sky value. Start to create the darker areas of the tree line as well as pull out some of the tree

trunks with an HB pencil. Don't create any details back there, just large areas in the trees that are shadows in the canopy.

Move back up to the foreground, finishing up one elephant at a time. Use an HB pencil to establish the third layer of value, creating a higher contrast on the elephants. Avoid putting any detail in these distant elephants. You want just enough value and contrast in the back elephants that make them easily identifiable, but not so much detail that the viewer's eye gets trapped back there.

 Visit artistsnetwork.com/drawrealisticanimals to download a free bonus demonstration.

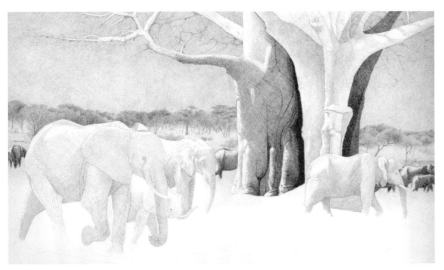

7 CONTINUE BUILDING UP THE BACKGROUND ELEPHANTS AND THE TREE

Continue your way forward through the background elephants and back into the tree. Treat the other elephants in the background the same as you did with the ones in step 6. Use an HB pencil to establish the darks.

Approach the tree from the back forward. The Baobab tree basically has large ribs that protrude out, creating a layered effect. You want to work on the ribs in the back first and move up to the ones in the front last. Find your darkest dark with in the ribs of the tree

by pushing the darks in the deep rib so that you can better judge all the other values in the drawing as you move forward. There are already two layers of value on the tree, so build the third layer with an HB pencil. Start to identify the minor folds and wrinkles in the trunk as you do. The deep dark rib will be layered in again with the 2B pencil, getting that nice rich dark. All this should be done with crosshatching and a sharp pencil.

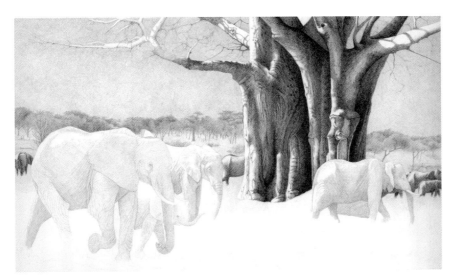

8 PULL OUT THE TREE TEXTURES AND SHADOWS

Continue to pull the HB layer of value up and into all the tree branches. Start to pull out more of the Baobab tree bark texture of the wrinkles. Use a 2B pencil to pull some deeper shadows out to the larger crevices of the ribs, helping to create a separation of one area from another.

Each section of this tree can be thought of as a cylinder. The left side of each curved section will have a soft transition line into

the highlight. You have the overall large cylindrical shape of the tree and within that, you have smaller cylindrical areas, and then even smaller cylindrical areas within those.

In the darker areas of the tree, use a 2B pencil to really push those darks and help establish the high contrast desired in this drawing. Now that the tree is almost finished, you can see how the value in the sky is falling into place. Perfect!

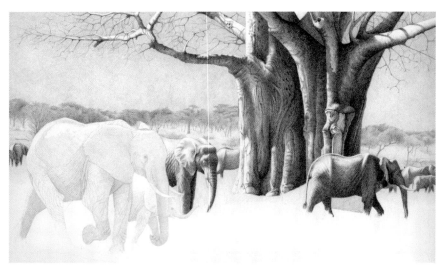

9 FINISH THE TREE LIMBS AND BUILD THE MID GROUND ELEPHANTS

Finish the tree limbs in the upper canopy. Use sharp HB and 2B pencils to redefine some of the larger branches and pull out the smaller ones. Between the sky value and the highlighted areas on the tree limb, the look of a brightly lit surface is achieved.

Build up the middle ground elephants, first with a sharp HB pencil to get the third layer of value in the shadow areas. As you do this, start to pull the values up into the wrinkles and folds of the skin. The light is coming from the left, so all the hard lines will be on the right with the softer edges on the left.

You want these mid ground elephants to have a louder visual voice, so push the contrast one step further than the background elephants. Build a fourth layer of value in the core shadow areas with a sharp 2B pencil. Pull some of that value up into the wrinkles, just not as far as you did with the HB pencil. With these elephants, you want detail in the mid value and highlighted areas, but not in the shadow areas.

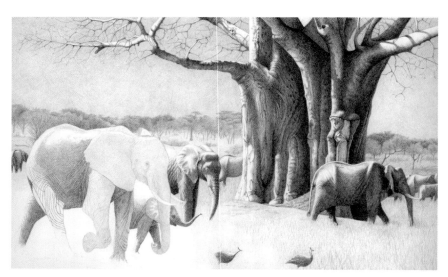

10 BEGIN THE GRASS AND GUINEA FOWL, AND CONTINUE BUILDING VALUE IN THE FOREGROUND ELEPHANTS

Finish the base of the tree and start to build the first layers of value in the grass areas with a 4H pencil. The grass is going to be light, so from the beginning make sure your pencil lines are going in the same vertical direction as the grass. Your pencil lines also need to be shorter in the background and get a little bit longer as they move to the foreground.

Start the two guinea fowl off as large ovals. From there, lay in the characteristics of the two birds. These birds are actually pretty dark with many tiny spots on them. Study them and see how the pattern flows over the birds. You can create a light grid system

flowing in the direction that the dots move over the bird. From there, simply fill in the spaces between the white dots. The birds can be built with the first three layers of value using 4H, 2H and HB pencils.

Move back onto the main focus of this drawing, the two elephants in the foreground. Use an HB pencil to build the third layer of value with crosshatching. Redefine the wrinkles as you go. As you get closer to the edge of the core shadow, lighten your hand pressure so that the edge feathers out, creating the needed soft edge.

Visit artistsnetwork.com/drawrealisticanimals to download a free bonus demonstration.

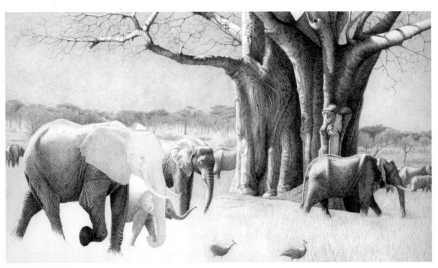

11 ESTABLISH THE WRINKLES

Establish the wrinkle details in the shadows of the front elephants. Use a 2B pencil to push the darks on the deeper creases of the folds, especially at the leg intersections and on the raised foot that is in shadow. Keep your pencil sharp and use scribbling rather than crosshatching, since the area is so small to work in.

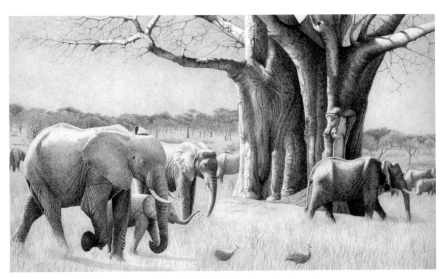

12 FINISH THE ELEPHANT HEADS AND DETAIL THE GRASS

Use an HB pencil to add the third layer of value on the head in the core shadow and redefine the wrinkles. Use crosshatching but keep your pencil lines extremely smooth on the ear, since it does not have much texture. Darken up some of the darker areas and deeper wrinkles with a 2B pencil.

Work the foreground grass with a 4H pencil to establish an overall base value, then go back over it with a 2H pencil. Continue using the 2H pencil to bring out the grass structure. Make sure your pencil lines are going in the same vertical direction as the grass. The grass farthest behind the front elephant should be more in clumps. As it gets closer to the viewer, start to pull out more of the individual blades. Keep in mind that you only need to do a few of these, the rest will just be perceived as grass by the viewer. You can also pull out the random small shrub as well as the base layer of the cast shadow from the elephants.

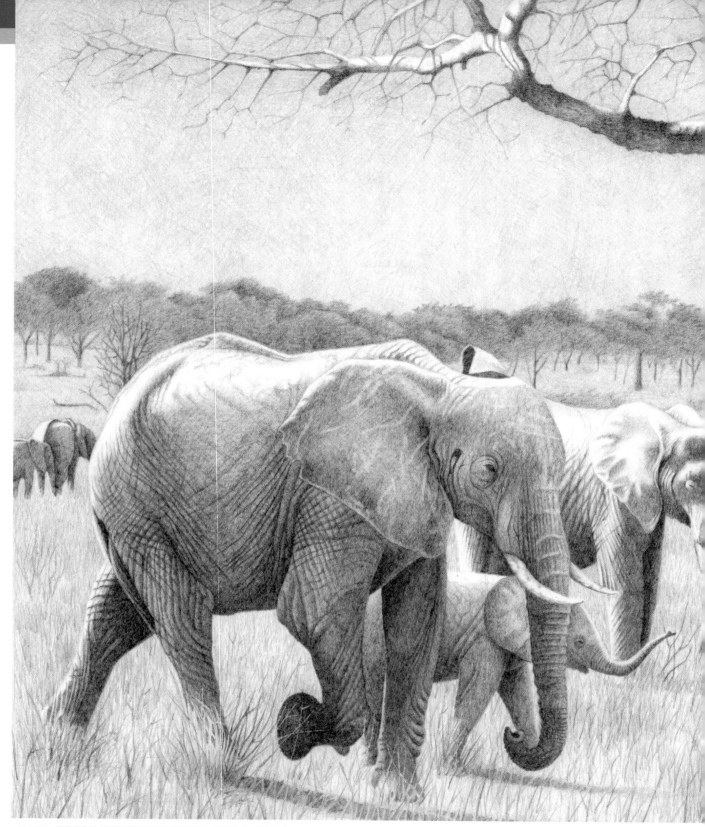

13 FINISH THE FOREGROUND AND GUINEA FOWL, AND PICK OUT THE HIGHLIGHTS

Finish the foreground area with a sharp HB pencil. Pull out more grass detail and darken up the random blades of grass and shrub. Finish darkening the cast shadow from the two elephants in the foreground as well.

Finish the two helmeted guinea fowl by adding a fourth layer of value with a 2B pencil. Try not to lose the white spots that you found along the birds' bodies. Use a sharp 4B pencil to add the final darks on the front of the birds and the markings on their heads.

Push the darks on the head of the front elephant a bit more with a 2B pencil. The area where the ear meets the head and the mouth needs to be made a little bit darker, as well as some of the spots towards the edge of the ear. Darken other areas as needed with a 6B pencil.

Visit artistsnetwork.com/drawrealisticanimals to download a free bonus demonstration.

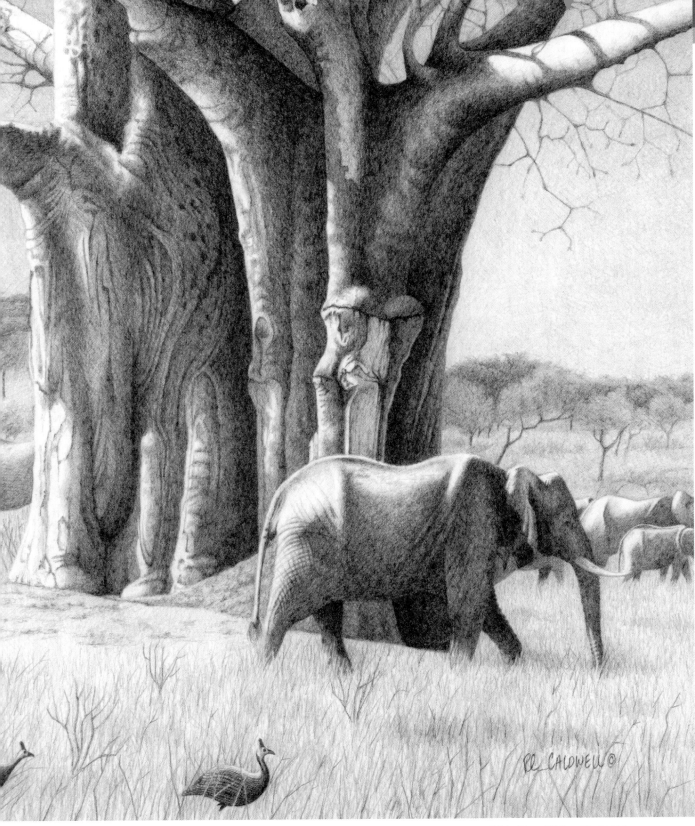

Shape your kneaded eraser into a flat disc. Use the thin edge to pick out the highlights of the creases on the ear. Make sure to turn the eraser often because the edge will get dirty fast.

Thirty-Three (African Elephants)
Graphite on Arches #300 (640gsm) cold-pressed watercolor paper, 10" × 17" (25cm × 43cm)

 Visit artistsnetwork.com/drawrealisticanimals to download a free bonus demonstration.

Three Camels (Dromedary Camel)
Graphite on Arches #300 (640gsm) cold-pressed
watercolor paper, 7"× 14" (18cm × 28cm)

Index

Visit artistsnetwork.com/drawrealisticanimals to download a free bonus demonstration.

About the Author

Robert Louis Caldwell spent his boyhood in the state of New York, where he learned to love the outdoors. He attended Virginia Commonwealth University in Richmond, where he graduated with a Bachelor of Fine Arts in 2000. He won several awards in college including an honorable mention in Strathmore Artist Papers' student illustration contest and a certificate of merit from the Society of Illustrators.

Never without his camera and sketchbook, Robert draws inspiration from familiar subjects using photographic references that is complemented by field studies to compose his drawings and paintings.

Robert is represented by Lovetts Gallery in Tulsa, Oklahoma, and Berkley Gallery in Warrenton, Virginia. His work has appeared in numerous national exhibitions, including Birds in Art; Art of the Animal Kingdom; Art and the Animal; and NatureWorks Wildlife Art Show & Sale. In 2010, *Ramsey's Porch (Mourning Dove)* was selected for the prestigious Birds in Art exhibition.

Published by North Light Books, an imprint of F+W Media, Inc., 10151 Carver Road, Suite 200, Blue Ash, Ohio, 45242. (800) 289-0963. First Edition.

Other fine North Light Books are available from your favorite bookstore, art supply store or online supplier. Visit our website at fwmedia.com.

18 17 16 15 14 5 4 3 2 1

DISTRIBUTED IN CANADA BY FRASER DIRECT
100 Armstrong Avenue
Georgetown, ON, Canada L7G 5S4
Tel: (905) 877-4411

DISTRIBUTED IN THE U.K. AND EUROPE
BY F&W MEDIA INTERNATIONAL LTD
Brunel House, Forde Close, Newton Abbot, TQ12 4PU, UK
Tel: (+44) 1626 323200, Fax: (+44) 1626 323319
Email: enquiries@fwmedia.com

DISTRIBUTED IN AUSTRALIA BY CAPRICORN LINK
P.O. Box 704, S. Windsor NSW, 2756 Australia
Tel: (02) 4560-1600; Fax: (02) 4577 5288
Email: books@capricornlink.com.au

ISBN 13: 978-1-4403-2931-9

Edited by Christina Richards
Designed by Aly Yorio
Production coordinated by Mark Griffin

METRIC CONVERSION CHART

To convert	to	multiply by
Inches	Centimeters	2.54
Centimeters	Inches	0.4
Feet	Centimeters	30.5
Centimeters	Feet	0.03
Yards	Meters	0.9
Meters	Yards	1.1

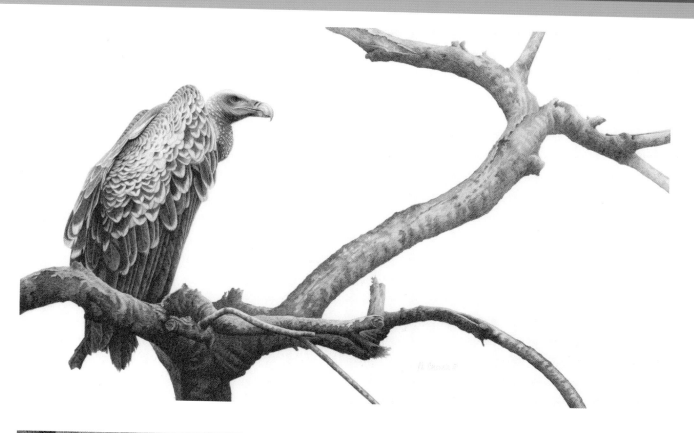

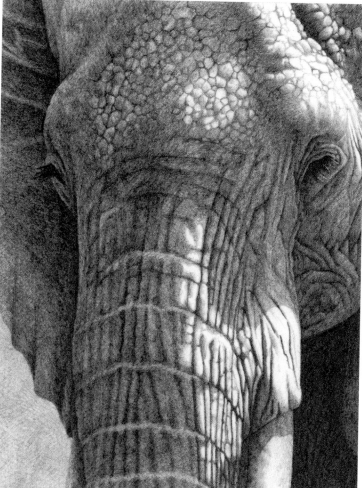

Acknowledgments

To my students, I would never have known the joy of teaching if it wasn't for all of you. Thank you!

To my friends and fellow artists Jan Martin McGuire and James Gary Hines II, thank you so much for introducing Africa to me.

Thank you to Terry Miller, for providing the foreword for this book.

And thank you to my editor Christina Richards for helping me to get all of the words in the right places.

Dedication

For Kristen and Jacob.

Ideas. Instruction. Inspiration.

Receive FREE downloadable bonus materials when you sign up for our free newsletter at artistsnetwork.com/Newsletter_Thanks.

Find the latest issues of *The Artist Magazine* on newsstands, or visit artistsnetwork.com.

These and other fine North Light products are available at your favorite art & craft retailer, bookstore or online supplier. Visit our websites at artistsnetwork.com and artistsnetwork.tv.

Follow North Light Books for the latest news, free wallpapers, free demos and chances to win FREE BOOKS!

Get your art in print!

Visit artistsnetwork.com/splashwatercolor for up-to-date information on *Splash* and other North Light competitions.